IMAGES
of America

ELKRIDGE

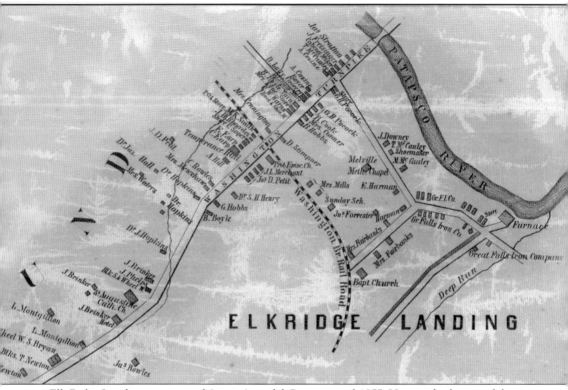

Elk Ridge Landing was part of Anne Arundel County until 1855. Here is the layout of the town in 1860. In the 1700s, the town's name appeared on government documents as Elk Ridge Landing (three words). As time went on, the first two words were combined as Elkridge, and since the Patapsco River filled in and was no longer navigable for big ships, the "Landing" was dropped. (Courtesy of the Library of Congress.)

ON THE COVER: The Elkridge Athletic Club, one of two baseball teams in Elkridge in the 1930s and 1940s, won the A.B.B. Middle Atlantic States championship in 1939. Here, the team is pictured after its victory in Holyoke, Massachusetts, where the tournament took place. In 1934, the team was named Maryland's Amateur State champions. In its division, the Southwestern County League, it claimed the championships in 1934, 1935, 1938, and 1939. (Courtesy of the Howard County Historical Society.)

IMAGES
of America

ELKRIDGE

Elizabeth Janney

ARCADIA
PUBLISHING

Published by Arcadia Publishing
Charleston, South Carolina

Printed in the United States of America

Library of Congress Control Number: 2012955004

For all general information, please contact Arcadia Publishing:
Telephone 843-853-2070
Fax 843-853-0044
E-mail sales@arcadiapublishing.com
For customer service and orders:
Toll-Free 1-888-313-2665

Visit us on the Internet at www.arcadiapublishing.com

This book is for the people of Elkridge.

CONTENTS

ACKNOWLEDGMENTS

Thanks go to the community of Elkridge for inviting me into your homes, your churches, your businesses, and your history. As it has preserved documents and objects that are testament to the history of Elkridge—from sewing machines to voting ledgers—the Elkridge Heritage Society was especially vital in creating this book. A special thank-you goes to Mary Bahr for sifting through the past with me and laughing along the way. I also appreciate Gale Sigel, Dave and Sandy Grabowski, Michele and Ray Miller, Howard Johnson, Polly Thornton, Judy Peddicord, the Mersons, and many others for having shared their stories of Elkridge with me.

Daniel Carroll Toomey has been an invaluable resource in compiling images and context for this publication. I cannot begin to express my gratitude.

Many thanks go to Kylie Carpenter and Paulette Lutz at the Howard County Historical Society for their assistance in finding elusive photographs in their collection.

Thanks go to my acquisitions editor, Lissie Cain, at Arcadia Publishing and to Danna Walker, who encouraged me to pursue my interest in history as an editor with *Patch*. Also, a thank-you goes to Sean Welsh for his support.

Special thanks go to my fiancé, Carlo Cardenas, who has put up with me through the book project and has listened to countless tales of Elkridge retold. I owe my parents a big shout-out for having faith in me to complete this project and for contributing to my desire to write and learn from day one. Thanks go to my brother, Oliver, for his enthusiasm and support. It means a lot.

Unless otherwise noted, all images appear courtesy of David Cardenas.

INTRODUCTION

Unassuming, Elkridge may appear on the surface as a town that grew up along US Route 1, but that is far from the case. Its history began in the 17th century when Capt. John Smith, who charted the East Coast looking for a place to settle, planted a Maltese cross with his crew in Elkridge, noting the rich clay along the river.

Captain Smith was not the only one making his mark in the Maryland town. Later on, the nation's first curved railroad bridge, which was later designated as a national landmark, would be built in Elkridge; architect Henry Latrobe designed it. Artists, baseball players, and politicians have emerged from Elkridge, which has been a major part of history then and now.

The town of Elkridge never used the name it was given. The Maryland General Assembly designated it Jansen Town in 1733 for unknown reasons, and the name did not stick when it formed in 1734. Instead, "Elk Ridge" was what people called the town that was situated along the Patapsco River valley in a land filled with elk and other natural resources.

After floods, after fires, and after being divided by war and highways, the heart of Elkridge has continued to beat since colonial days, and the spirit of its past lives on in the buildings, the river, the stories, and the people that have carried its history on for hundreds of years.

One

COMMERCIAL HUB OF ELK RIDGE LANDING

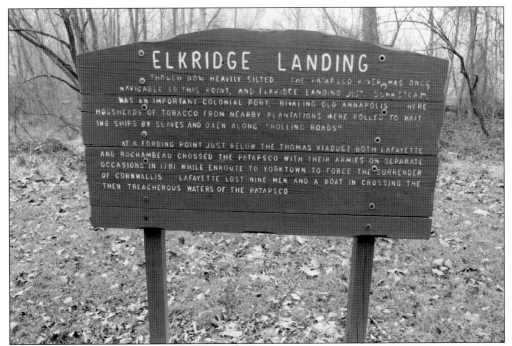

Capt. John Smith planted a bronze cross in Elkridge near the Patapsco River in 1608, according to the National Park Service. In his travel logs, Smith reportedly made note of the rich clay along the Patapsco River, where he and his crew paddled looking for minerals. He stated that the area was not inhabited. By surveying and marking the land, Smith claimed the territory for England. Three centuries later, it would become part of the Avalon area in Patapsco Valley State Park.

Settlers began farming in Elkridge and shipping tobacco from the Patapsco River. The Patapsco River enabled Elk Ridge to thrive as a deepwater port as early as 1690, according to the Maryland Department of Natural Resources. Here, slaves are depicted rolling barrels of tobacco from plantations down the "rolling road" to the river. In 1696, the governing body in Maryland, the

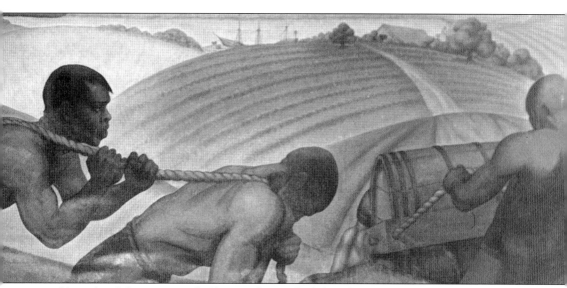

assembly, ordered the creation of rolling roads, on which barrels of goods could be rolled to ports. Elkridge resident Leonard M. Bahr (1905–1990), a professor at Maryland Institute College of Art, painted this mural, called *Slaves Rolling Hogsheads of Tobacco Down a Road*, in 1934. (Courtesy of the Enoch Pratt Free Library.)

Quakers had started congregating at the Elkridge Meetinghouse around 1670. The precise location of the building is not known, but according to a historian's account documented by the Maryland Historical Society in 1835, the trip there required crossing the Patapsco River. Attendees of the Elkridge Meetinghouse reportedly "loved its rural situation and quiet shade" in an area with "unusually large" trees. The Pierpont, Ellicott, Hayward, and Read families were said to have attended the Quaker meetings in Elkridge.

Arrowheads found in Elkridge were traced to Native Americans. According to *Maryland Historical Magazine*, a council met in Elkridge in 1692 at the home of Job Larkin to appoint rangers to keep watch over the Indians, who were in areas north of Elkridge. An excavation in the late 1960s along the Patapsco River revealed pottery dating back to 1800 BCE and indicated permanent settlement at what archaeologists called "the Elkridge site" until 1500 CE. (Courtesy of the Elkridge Heritage Society.)

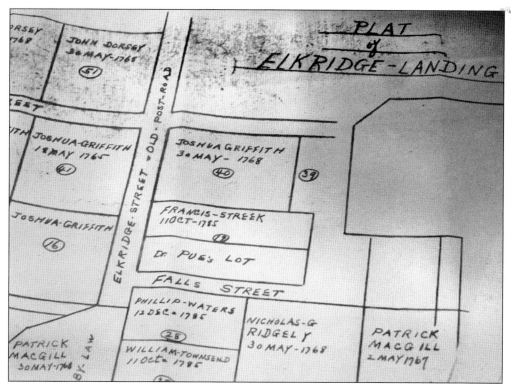

In 1733, the Maryland assembly ordered creation of a town called "Elk Ridge Landing, near the head of the Patapsco." Commissioners were to purchase 30 acres "convenient to the water" and survey the land so that a town could be built with 40 lots, numbered 1 to 40. This plat, drawn in 1933, was based on Elk Ridge Landing land records from the late 1700s. (Courtesy of the Elkridge Heritage Society.)

Originally, Elkridge was part of Anne Arundel County, founded in 1650. Settlers on the south side of the Patapsco River were later redistricted into Baltimore County but petitioned, in 1726, citing the "great inconvenience" of the county seat being near Joppa. The Maryland assembly redrew the boundaries so Elkridge was again part of Anne Arundel, until 1851, when Howard County formed. (Flag design by Charles Irby, courtesy of the Elkridge Heritage Society.)

One of the first land grants in what would later become Howard County was called Morning Choice. In 1689, Dr. Mordecai Moore was camping with a surveying party when he awoke before his companions and was moved by what he saw on the ridge of elk. "The mists were rising from the river, and the land sloped away . . . while behind was a little hill which would protect one from the northwest winds," according to an account of the event. Thinking it would be an ideal spot for a home, Moore laid out 1,300 acres and named the plot Morning Choice based on his morning experience. He was deeded the land, which later became part of the Belmont estate.

Charles Carroll of Carrollton established Hockley Forge in 1760. A mill, distillery, and a telegraph equipment company were later built on the site, according to the Maryland Historical Trust. At the mill, corn was ground into flour and then shipped from the landing on the Patapsco River. What remains of the Hockley Gristmill complex on Levering Avenue is of "national importance," say Howard County archivists, because it was built around 1794 and reflects the shift from a tobacco-centered economy to one based on grain.

Land on River Road was patented as Foster's Fancy in 1649. Historians think the building may have housed the keeper of Hockley Gristmill. The house on the property was built in the 1700s, according to Maryland Historical Trust, and a bullet from the 1860s found in the living room wall was believed to have dated from the Civil War.

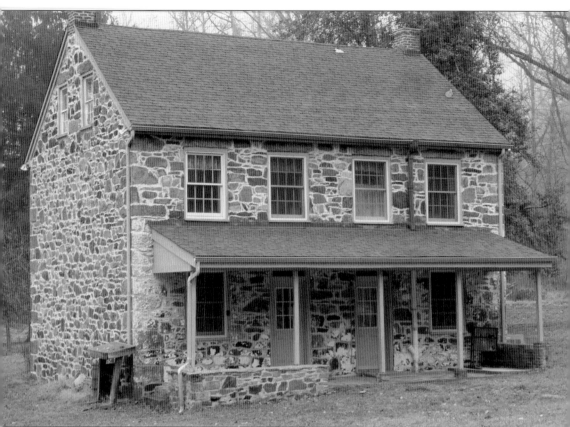

With the discovery of ore in the area, iron making was the first industry to take hold in the Patapsco River valley. In 1761, ironmaster Caleb Dorsey founded Dorsey's Forge. Located north of the present-day Howard County line along the Patapsco River, Dorsey's Forge helped produce bayonets and cannons for the American Revolution. Water from the river powered the operation, where at least nine slaves worked as of 1787, making items like horseshoes and nails. In 1815, Pennsylvania transplants Benjamin, James, and Thomas Ellicott bought the business. The entrepreneurial brothers renamed it Avalon Iron Works in 1822 and diversified the business, adding Avalon Rolling Mill and Avalon Nail Factory. By the mid-19th century, Avalon was a small industrial village employing more than 100 people. In 1868, a flood claimed the entire mill, factory, and forge. Pictured is one of two remaining structures, now in Patapsco Valley State Park.

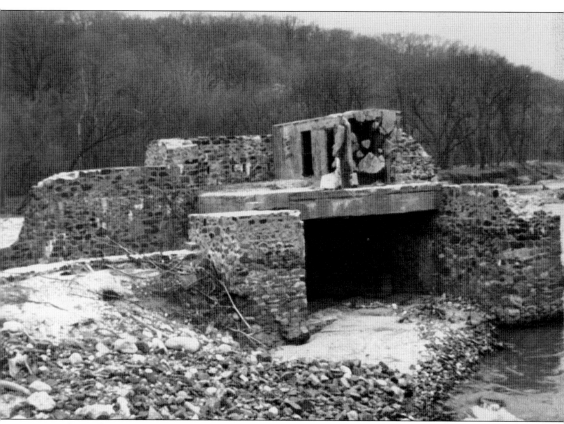

Water from the Patapsco River powered nearby industrial operations. Dammed up water was channeled into what was called a millrace. From the millrace, it flowed into a waterwheel, which turned a gear shaft. At Dorsey's Forge in the 1700s, the water created the force needed to open and close the bellows, which fanned the fire in the forge. In the 1800s, waterpower raised and lowered a hammer that pounded pig iron into nails at Avalon Iron Works. Pictured are the remains of the Avalon Dam after the flood of 1868 washed away the industrial village of Avalon. (Photograph by Patapsco Valley State Park, courtesy of the Baltimore County Public Library Legacy Web Photography Collection.)

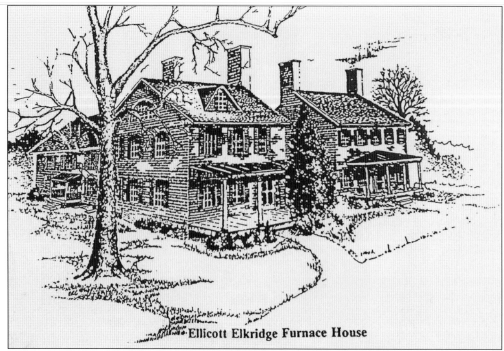

Ellicott Elkridge Furnace House

In 1744, surveyor James McCubbin built a tavern on what is present-day Furnace Avenue. It is believed that the Continental Congress met at least once in McCubbin's tavern. Ironmaster Caleb Dorsey built the Elkridge Furnace next to the tavern in 1755. The Ellicott brothers purchased the property in 1810. They modernized the furnace and built a manor house as an addition. (Courtesy of the Howard County Historical Society.)

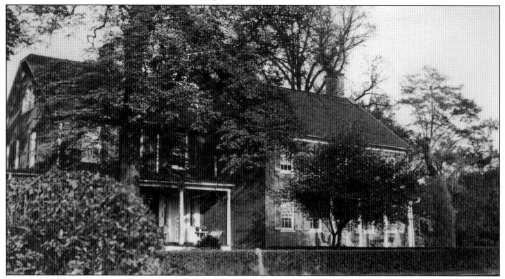

The Elkridge Furnace operation became known for its high-quality pig iron, or crude iron, which was usually refined to produce steel; pig iron was used in the production of materials for guns and cannons for the Revolutionary War. Andrew Dorsey, who with his brother later bought the Elkridge Furnace, was a member of the Elk Ridge Battalion of 1776. (Courtesy of Daniel Carroll Toomey.)

The Viaduct Hotel was built of the same granite from the Patapsco River used to construct the Thomas Viaduct. From the second-story balcony of the hotel, visitors could see the viaduct and the river. Guests at the hotel, the construction of which the B&O Railroad commissioned in 1873, could stay overnight in the Gothic-style building between parts of their journeys; other travelers used it as a meeting place along the way. (Courtesy of the B&O Railroad Museum.)

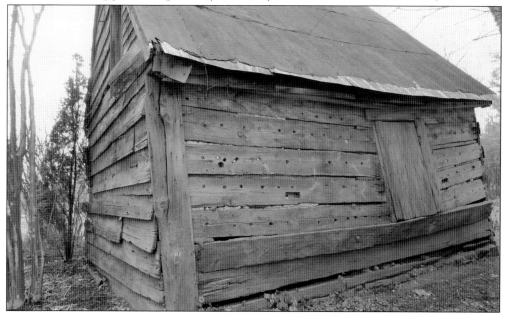

In addition to the tavern, manor house, and furnace, there were buildings on the Elkridge Furnace complex that housed slaves. The Ellicott family, which purchased the furnace in 1810, was Quaker and did not believe in slavery. It is thought that they used the outbuildings to house travelers on the Underground Railroad. (Courtesy of the Elkridge Furnace Inn.)

19

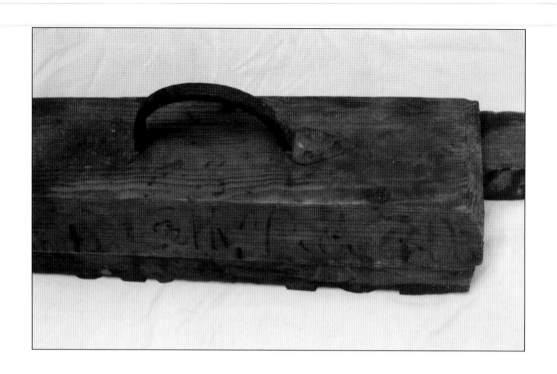

As of 1826, after the Ellicott family had acquired and rebuilt it, the Elkridge Furnace was reported to be 32 feet high and 8.5 feet in diameter. Iron ore mined from the Patapsco River valley went into the furnace and out came crude iron, known as pig iron. The pig iron was then cast in blocks, which could be refined to produce steel. By 1840, the furnace in Elkridge had an annual output of 2,000 tons of pig iron. Pictured is the branding iron with "Elkridge Furnace" on it. (Both, courtesy of Daniel Carroll Toomey.)

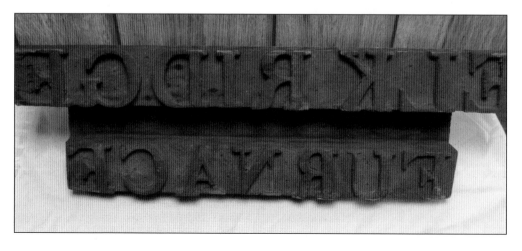

Two

Transit by Road, Rail, and Wire

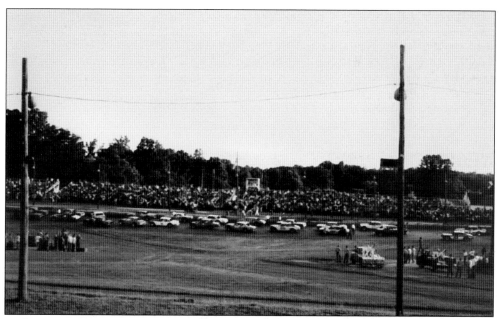

In the 1950s, Dorsey Speedway consisted of an oval track with a swamp in the middle. However, after several vehicles ended up in the swamp, the track was altered into a figure eight. Cars did several laps around the quarter-mile track in races, which were a popular spectator sport on Friday nights. Dorsey Speedway hosted races from 1951 to 1985. (Courtesy of Al Torney.)

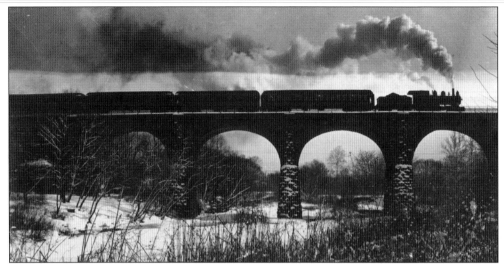

In 1835, the B&O Railroad built a bridge over the Patapsco River, called the Thomas Viaduct. At the time of its construction, the bridge was the largest in the country, according to the Maryland Historic Trust. Benjamin Henry Latrobe, who was an engineer with the railroad, designed the structure. (Courtesy of Daniel Carroll Toomey.)

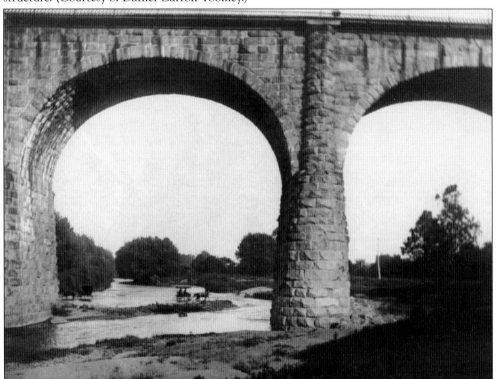

The Thomas Viaduct was named to honor president of the B&O Railroad Philip E. Thomas. Historians said its construction marked the beginning of railway infrastructure. For those traveling on land, ferry service was required to cross the Patapsco River. Here, horse and buggy stand below the viaduct in the river, which was no longer navigable due to shallowness caused by ships pouring their ballasts out in the water in the 18th century. (Courtesy of the Elkridge Heritage Society.)

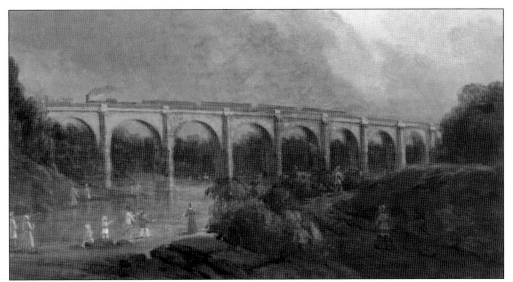

Skeptics who did not believe the bridge's curved arches could withstand the weight of trains called it "Latrobe's Folly" in a jab at the architect Benjamin Latrobe. His brother John Latrobe painted this scene after the Thomas Viaduct was constructed. John Latrobe lived on nearby Lawyers Hill. Magazines including *Harper's Weekly* and *US Illustrated* feature sketches of the marvel in their publications. The *Ladies' Companion* includes this print in its July 1939 issue. (Oil painting by John H. Latrobe, courtesy of the Maryland Historical Society.)

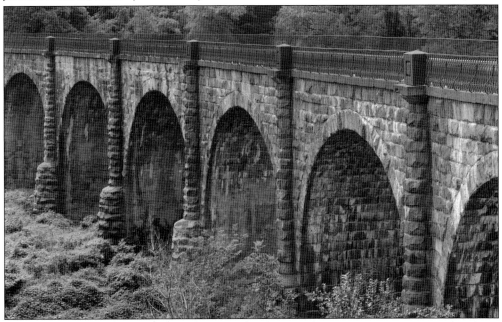

Eight arches comprised the Thomas Viaduct, which was made of local granite. It spanned 612 feet long, contained 24,476 cubic yards of stone, and cost $142,236.51 to build, according to the National Register of Historic Places. The railroad bridge was designated as a National Historic Landmark in 1964 and a National Civil Engineering Landmark in 2011. This picture was taken in 1970 as part of the Historic American Engineering Record. (Photograph by William Edmund Barrett, courtesy of the Library of Congress.)

For horse travel in the early days of Elkridge, Post Road was the major thoroughfare. Established in 1745, the road was located south of Main Street by Railroad and Paradise Avenues and passed through Elkridge Heights. The road, which was the first to span from Baltimore to Washington, was reportedly in such poor shape that, in 1812, Maryland lawmakers commissioned creation of a stone road. Daniel Carroll Toomey, whose family owned the manor house at the Elkridge Furnace complex from 1904 until 1971, found this freestanding hitching post for horses in front of the property on Furnace Avenue. (Courtesy of Daniel Carroll Toomey.)

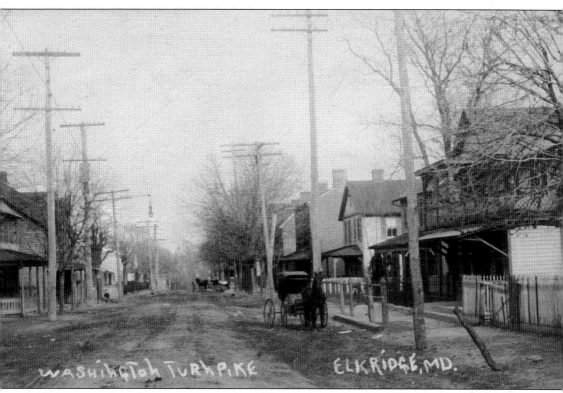

The Washington Turnpike was constructed in 1817 where Main Street in Elkridge is now. Designed to connect the cities of Baltimore and Washington, the turnpike spanned 37 miles total, according to the Maryland Historical Trust. Travelers on turnpikes were required to pay a toll for passage. Once the toll had been paid, the collector would turn the bar or gate (the pike) blocking the way. When the road was laid in Elkridge in the early 19th century, businesses were drawn to the thoroughfare. By the second half of the 19th century, "Elkridge was a village of shopkeepers," according to the Maryland Historical Trust. (Courtesy of the Elkridge Heritage Society.)

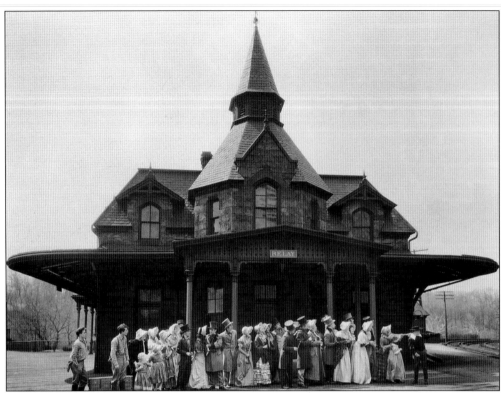

Before steam engines and locomotives dominated the tracks, horses pulled train cars that were hooked into rails. The transfer point for tired horses between Baltimore and Ellicott Mills was located next to Elkridge and was named "Relay." The cost of taking a train car pulled by a horse was 75¢ when the first trip was made in 1830. As the B&O Railroad laid its tracks across the Thomas Viaduct in the 1830s, Relay rose to even greater prominence as a transportation hub. In 1872, the B&O Railroad constructed the Viaduct Hotel, a travel complex consisting of a hotel and train station that overlooked the Patapsco River. (Both, courtesy of the B&O Railroad Museum.)

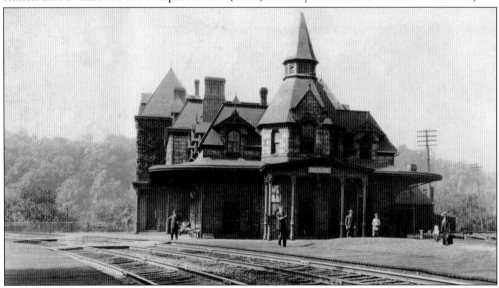

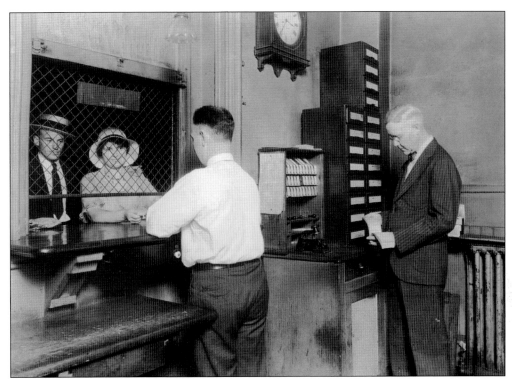

An establishment called Relay House was initially the place to stop for travelers to eat between Baltimore and Ellicott Mills. With the advent of train travel, a combination hotel-train station emerged in 1872–1873, called the Viaduct Hotel at Relay Station. The Baltimore & Ohio Railroad Company commissioned the Viaduct Hotel's construction in 1872. Ephraim Francis Baldwin was the architect. He also designed Camden Station and worked on projects in and outside of Baltimore, including the College of Notre Dame of Maryland, the Baltimore Sun Building, and St. Joseph's and St. Agnes hospitals. Below, the Viaduct Hotel is pictured in winter. Above, a couple stands at the ticket counter inside Relay Station. (Both, courtesy of Daniel Carroll Toomey.)

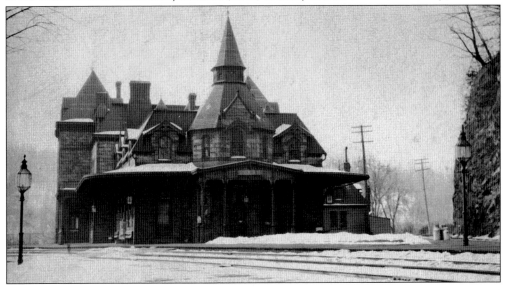

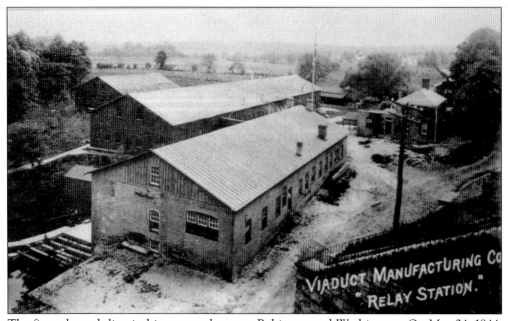

The first telegraph line in history was between Baltimore and Washington. On May 24, 1844, Samuel B. Morse sent the inaugural telegram. The message—"What hath God wrought?"—was carried through Elkridge wires as it made its way from the Supreme Court in Washington, DC, across the Thomas Viaduct to the B&O Depot in Baltimore City. (Courtesy of the Elkridge Heritage Society.)

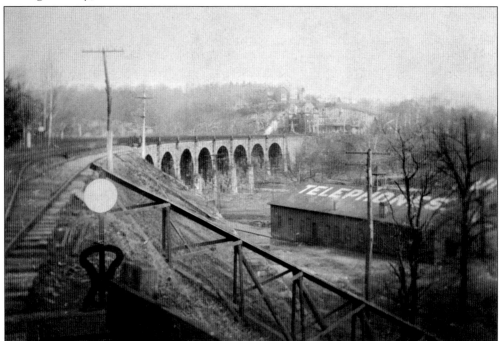

The Viaduct Manufacturing Company, which opened in 1871, produced materials for communication, primarily telegraph instruments. After the invention of the telephone in 1876, the company started manufacturing telephone products. (Courtesy of the Elkridge Heritage Society.)

From 1878 to 1883, Viaduct Manufacturing Company was the licensed manufacturer for the American Bell Company. The following advertisement from 1896 states the Viaduct's 18 years of experience and quality magneto bells make it the best option for telephone products: "You cannot afford to purchase cheap goods of this character . . . if your bell does not ring, your telephone is of no service." (Courtesy of Daniel Carroll Toomey.)

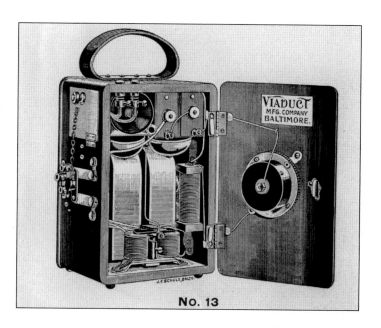

NO. 13

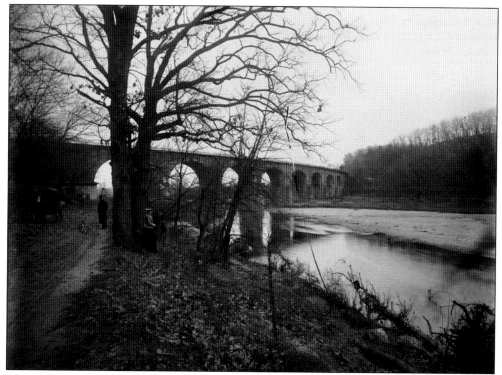

The arches of the Thomas Viaduct were constructed high enough that ships would be able to pass under them, but with the Patapsco River's increasing shallowness, few large vessels made the trip. Here, a couple stands near the Thomas Viaduct with horse and buggy in the Patapsco River Valley. (Courtesy of the Smithsonian Institution, Archives of American Gardens, Dr. G. Howard White Jr. Collection.)

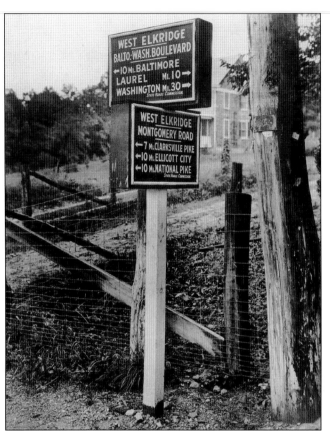

These signs along US Route 1 are from the early 20th century. At the bottom of the signs from West Elkridge is a credit to the State Roads Commission. Founded in 1908, the State Roads Commission was the inception of the State Highway Administration. (Courtesy of the Maryland State Archives.)

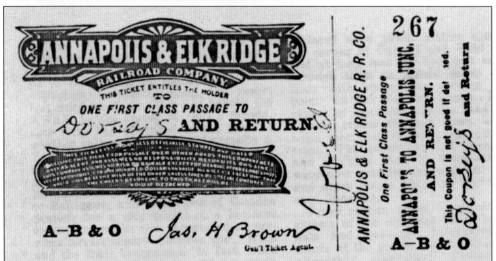

Steam-powered trains on the Annapolis & Elk Ridge Railroad traveled between Annapolis and Annapolis Junction after Christmas 1840. Between June and November 1866, the railroad line served more than 15,000 passengers. The intention was for the line to reach Elkridge, but the tracks did not get that far. In 1886, the company changed its name to Annapolis, Washington & Baltimore Railroad as part of a financial reorganization. (Courtesy of the Anne Arundell Historical Society.)

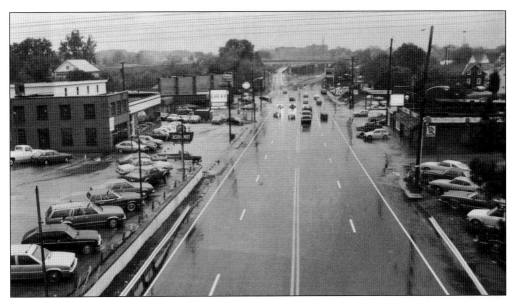

In 1917, construction began on US 1, which is the current US Route 1 or Washington Boulevard. When Route 1 was built, the business district along the Washington Turnpike and Main Street in lower Elkridge shifted. Here, the new highway is pictured with businesses sprouting up around it. (Courtesy of the Elkridge Heritage Society.)

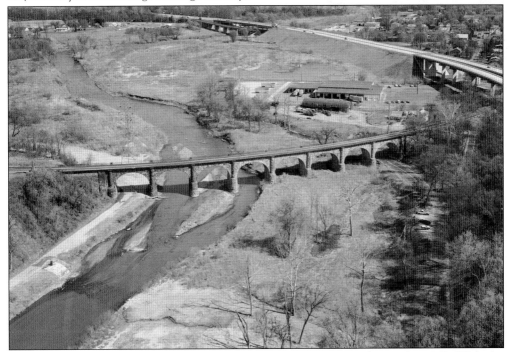

The Thomas Viaduct at the Patapsco River is pictured from the southeast after 1968. With the construction of the Harbor Tunnel in 1957, a new highway, Interstate 895, grew up near the viaduct, as part of a project through the Maryland State Roads Commission to improve the flow of traffic over rivers like the Patapsco to Baltimore. (Courtesy of the Library of Congress, Historic American Engineering Record.)

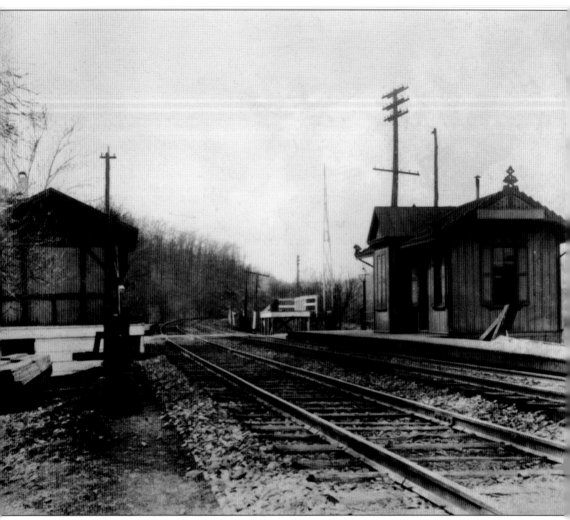

Elkridge Station, built in 1875, was located near Main Street. The agent for most of the station's existence was Charles V. Hubbard Sr. He was said to have handled most of the station's business, from tickets and telegraph operations to freight and records. His assistant Albert Carter wound the gates so they would rise as trains approached and lower when they passed. This view of the tracks faces Lawyers Hill. The station closed after 1914, according to the town's bicentennial journal. Later, a commuter rail station also opened in Elkridge, according to the October 8, 1981, edition of the *Howard Sun*. (Image donated by Ruth and Dave Anderson, courtesy of the Elkridge Heritage Society.)

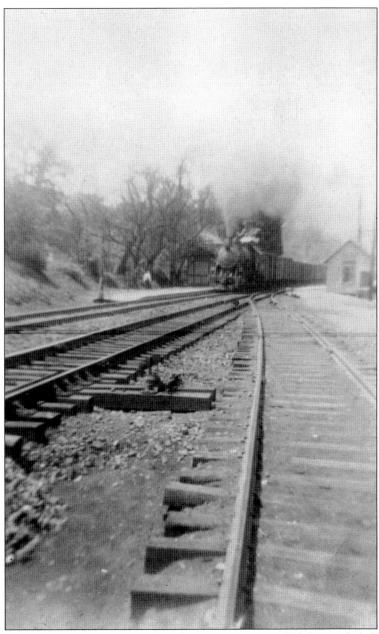

In the first half of the 19th century, a railroad company was founded that included Elkridge in its name. The Annapolis & Elk Ridge Railroad Company began making trips in 1840. In spite of its name, the railroad never made it to Elkridge. The tracks were laid southwest of Elkridge, in an area that became known as Annapolis Junction; it was at this location where the B&O tracks to Baltimore met the Annapolis & Elk Ridge tracks. The Annapolis & Elk Ridge Railroad Company ran stations in downtown Baltimore City and Odenton, among other places. Before the turn of the century, the Annapolis & Elk Ridge Railroad Company changed hands, and by 1935, it had disbanded completely. Pictured is a locomotive along the Baltimore & Ohio Railroad line, approaching Main Street in lower Elkridge. The picture was taken after construction of Elkridge Station in 1875. (Courtesy of the Elkridge Heritage Society.)

While building the Baltimore-Washington Turnpike in 1914, the Maryland State Roads Commission made the decision to divide Main Street in Elkridge in half. As a result, the northern part of Main Street became a dead end. Residents on the north and south ends of Main Street disagreed as to whether there should be an underpass or at-grade crossing. Later, an underpass was built after Catherine Rigg Laynor was killed while crossing the railroad tracks. Her husband, Roger Laynor, was a leader of Howard County's Democratic Central Committee and served in the Maryland House of Delegates and as head of the Alcoholic Beverage Division in the state comptroller's office. Pictured is the underpass on Main Street from two angles. (Both, courtesy of the Elkridge Heritage Society.)

Three

WARTIME IN ELKRIDGE

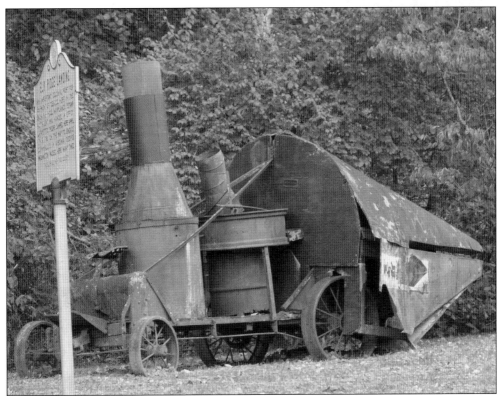

During the Revolutionary War, Elkridge helped manufacture iron products, like cannons, thanks to its industrial operations along the Patapsco River. On Old Washington Road, a sign states that Zachariah Hood was hanged here in effigy. Hood was the only stamp collector in Maryland, charged with collecting taxes for England from the colonists.

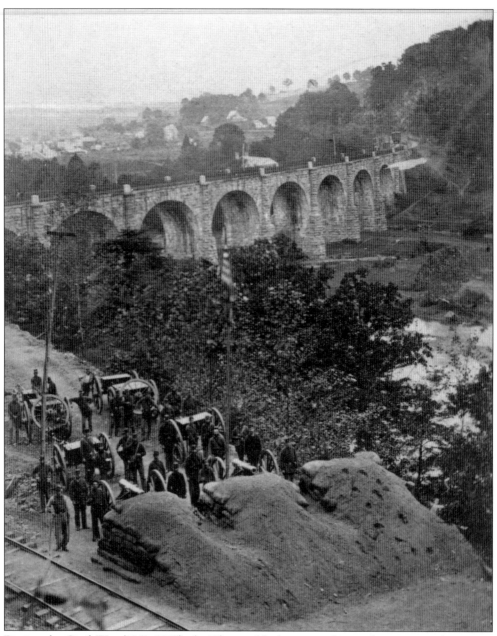

During the Civil War (1861–1865), the Thomas Viaduct was of critical importance because it provided exclusive access to the nation's capital. It was a vital connection, located on the B&O Railroad's main line, providing the link across the Patapsco River from Baltimore to Washington, DC. As such, it was crucial that the Thomas Viaduct be protected. In May 1861, Brig. Gen. Benjamin Butler and his Union troops saturated the area after receiving orders to occupy Relay. General Butler brought 2,080 men with him, from the 6th Massachusetts and 8th New York Regiments. In addition, the Boston Light Artillery joined the force under the direction of Maj. Asa M. Cook. Together, they surrounded the viaduct on both the Baltimore and Howard County sides. Behind soldiers stationed on the Baltimore County side, the village of Elkridge is visible. (Courtesy of Daniel Carroll Toomey.)

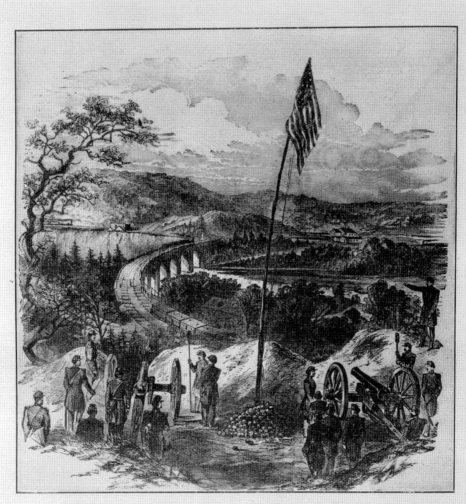

BOUQUET BATTERY, COMMANDING THE VIADUCT ON THE PATAPSCO RIVER ON THE BALTIMORE & OHIO R. R. NEAR RELAY HOUSE.

Among those summoned in May 1861 to guard the area around the Thomas Viaduct were soldiers from the Massachusetts 6th Regiment. Some camped along Elkridge Heights on the Howard County side of the railroad bridge, while others stayed on the Baltimore County side. Those in Elkridge set up a post that was called Camp Essex. According to an account published in 1862 detailing the activities of the Massachusetts volunteers during the Civil War, the soldiers considered their post a critical one. "The importance of this post can hardly be underestimated," the report states, noting Elkridge is where the Baltimore & Ohio Railroad "passes over a massive stone viaduct, the destruction of which, by blowing up, might be easily accomplished in the absence of a vigilant guard." The account stated that the railroad line provided the only direct connection with the capital, and daily, there were 3,000 to 5,000 troops crossing the viaduct. (Courtesy of the B&O Railroad Museum.)

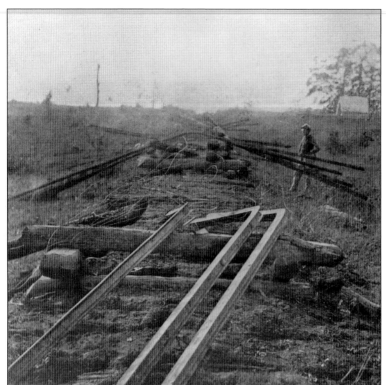

Soldiers dismantled railroad tracks to block the flow of supplies to their enemies during the Civil War. To prevent any damage to the Thomas Viaduct, which was built in 1835 and provided passage for trains on the B&O Railroad to Washington, DC, Union soldiers guarded the structure heavily. (Courtesy of the B&O Railroad Museum.)

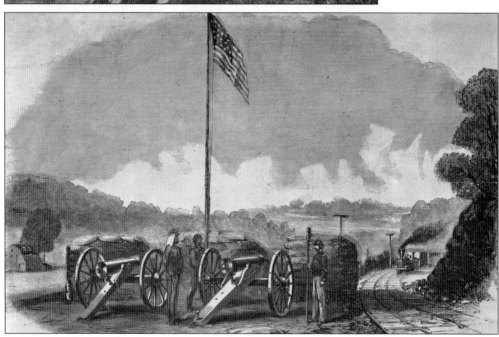

Harper's Weekly published this sketch of the sandbag battery stationed near the Thomas Viaduct in its June 1, 1861, issue. A group of soldiers from Massachusetts made up the group, which positioned a pair of cannons in front of the railroad bridge. The men erected barricades out of sand to protect themselves. (Courtesy of the B&O Railroad Museum.)

Soldiers from the 1st Massachusetts Battery man the cannon on Elkridge Heights. Despite the fact that it was wartime, the beauty of Elkridge was not lost on the soldiers, who sent word back home detailing what they found. In particular, they mention the "peaceful meadows of velvet green, the quiet cattle grazing, and the calm heavens," in a dispatch from the field published in the *New York Times* on May 11, 1861. "It was difficult to realize in this holy peace, that . . . bullets and cold steel were on the other side of this high hill, ready to do a terrible work, and illustrating a commotion which will startle the world." (Both, courtesy of the Massachusetts Commandery, Military Order of the Loyal Legion, and the US Army Military History Institute.)

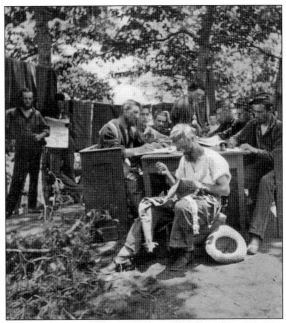

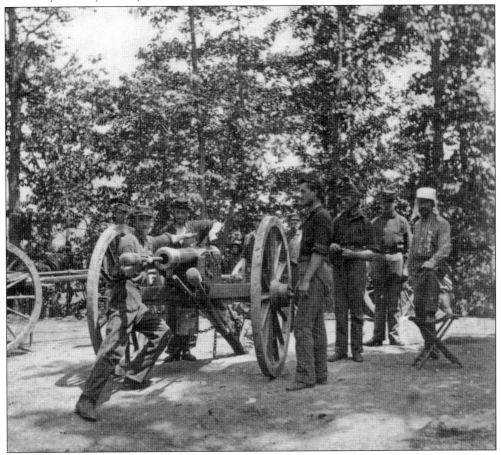

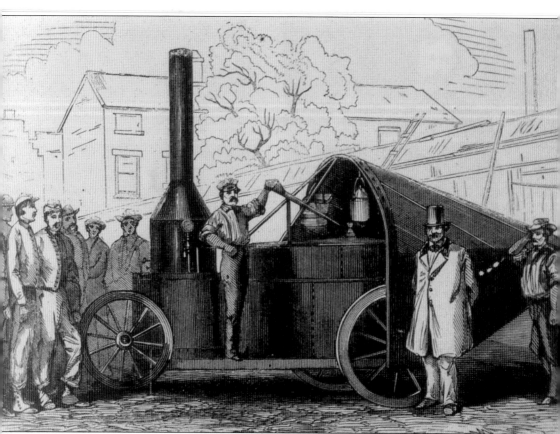

The Massachusetts infantry intercepted this steam gun on its way from Baltimore to Harper's Ferry, West Virginia, where the Confederate armies were stationed. Steam power resulted in the spinning of a barrel within the gun. Then, it would be fed ammunition before firing. Intercepted by Col. Edward Jones in Ellicott Mills in May 1861, the steam gun was brought to the Relay House, where the Massachusetts regiment had set up camp under the direction of Brig. Gen. Benjamin Butler. From there, the steam gun was employed by Union troops to frighten people from coming near the Thomas Viaduct during the Civil War. It was called the Winans Steam Gun, after an inventor who may or may not have created it. (Courtesy of the B&O Railroad Museum.)

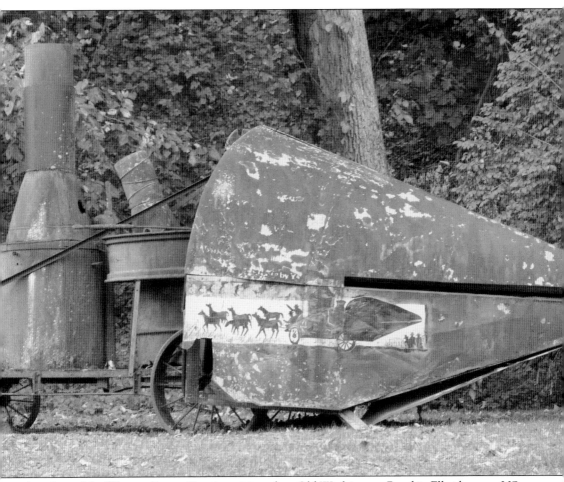

A replica of the Winans Steam Gun is positioned on Old Washington Road in Elkridge near US Route 1. The conical shield was designed to protect soldiers from enemy fire. The steam gun was a marvelous invention that drew the attention of the press in 1860. The media credited Ross Winans, whose shop in Baltimore fixed mechanical contraptions, with creating it. However, historians have disagreed with that account and identified William Joslin, an Ohio mechanic, with inventing the steam gun in Boston and bringing it to Baltimore on display. From there, Joslin was attempting to take the steam gun to Confederates at Harper's Ferry when it was captured and ultimately brought to the Union camp at Relay in 1861. A replica of the steam gun was made in 1961 to mark the 100-year anniversary of its capture. (Courtesy of the Elkridge Heritage Society.)

George Washington Dobbin (1809–1891) built a summer home, called The Lawn, on Lawyers Hill in Elkridge in 1840. During much of the year, Dobbin resided in Baltimore, where he was named to the Supreme Court for Baltimore City in 1867, according to the Maryland State Archives. After the Civil War, Judge Dobbin donated land for what he called a "neighborhood parlor" to be built on Lawyers Hill. At the time, Lawyers Hill was split politically. Essentially, the establishment, called the Elkridge Assembly Rooms, was to be a place for Confederate and Union sympathizers to come together for entertainment. The Elkridge Assembly Rooms helped break the postwar tension, opening its doors in 1871 with one major rule: there was to be absolutely no talking about politics inside. In the years that followed, the Fourth of July became a signature event at the neighborhood gathering place. (Courtesy of the Elkridge Assembly Rooms.)

Dances, plays, and musicals were on the menu at the Elkridge Assembly Rooms. Titles on stage ranged from *The Merchant of Venice* to *Beauty and the Beast*. The Elk Ridge Amateur Dramatic Association performed shows while the rest of the neighbors watched, setting aside their political differences. Approximately 12 families lived on Lawyers Hill in post–Civil War Elkridge, according to local historians. As the years went on, the plays became so popular they attracted an audience from outside of Baltimore. In the 20th century, the Wayside Players took to the stage at the Elkridge Assembly Rooms as well. (Both, courtesy of the Elkridge Assembly Rooms.)

Having served as a medic during World War I, Bruce Brumbaugh returned to Maryland to complete medical school and then went on to deliver most of the babies in Elkridge. Brumbaugh was the Elkridge physician from 1919 to 1980, according to the *Baltimore Sun*, which reported that the doctor from Caroline County came to Elkridge to fill in for a physician who had become ill in 1919; Brumbaugh ended up being the primary doctor for the next 61 years. Office visits were $2, and house calls cost $3. (Both, courtesy of the Elkridge Heritage Society.)

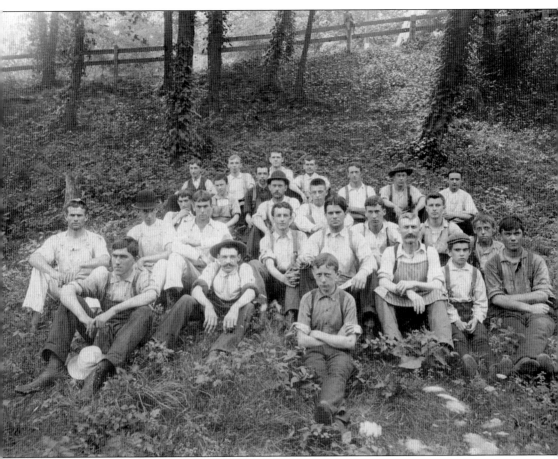

Patapsco Valley State Park helped provide men in the first half of the 20th century with a sense of purpose. From 1933 to 1942, the Civilian Conservation Corps (CCC), established by Pres. Franklin D. Roosevelt, created jobs for young men centered on natural resources. Two camps of CCC members were assigned to work in Patapsco Valley State Park, according to the Maryland Department of Natural Resources. Members of the CCC assisted with reforestation efforts and built the stone picnic areas and sidewalks in the park's Glen Artney and Orange Grove areas. The workers set up camp in the Avalon Area, where members of the United States' first camp of Conscientious Objectors would subsequently plant their roots. The Conscientious Objectors' camp opened in May 1941 and provided a place for men who said their religious beliefs prevented them from serving in World War II. As an alternative to military service, the federal government created opportunities to provide community service in places like forests and hospitals. (Courtesy of Patapsco Valley State Park.)

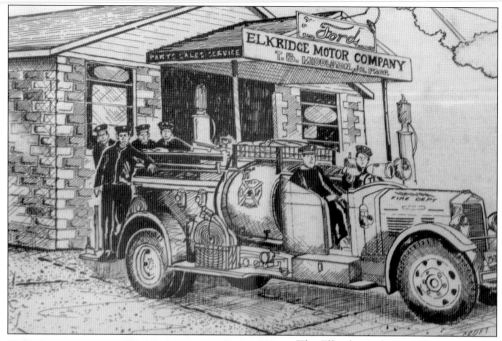

The Elkridge Volunteer Fire Department was built in 1944. The Elkridge Motor Company was the previous occupant of the space on Old Washington Road. An Elkridge resident drew this sketch of the fire department's predecessor. (Courtesy of the Elkridge Heritage Society.)

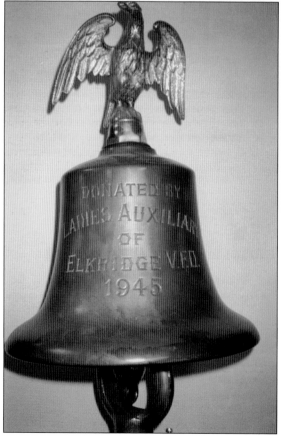

The Elkridge Volunteer Fire Department became the center of the community in the early 20th century. Volunteers started the organization in 1942, during World War II, as a way to give back, according to the daughter of two founding members. The ladies auxiliary of the volunteer fire department donated this bell to the fire department in 1945. (Courtesy of the Elkridge Heritage Society.)

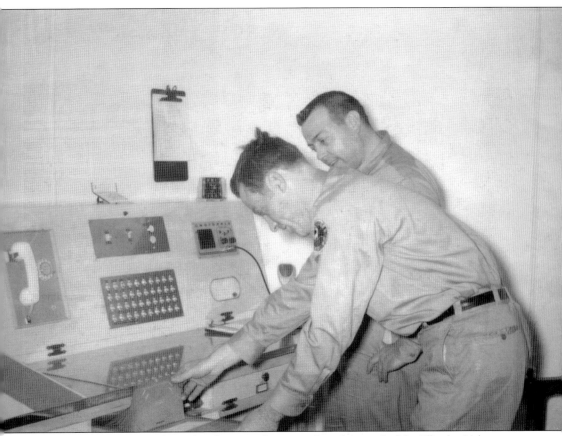

Tom Evans and Norris Ward stand in the control room, or "watch room," of the Elkridge Volunteer Fire Department, which was founded in 1942 as a civilian defense operation. At the time, the threat of air raids in Elkridge "was very real," according to the department's historians, because of the proximity of Elkridge to Washington, DC. Citizens of Elkridge received reports of the war through the radio and determined in April 1942 that they would raise $7,000 needed to start the department. The cause moved from a temporary operation to a permanent fixture in Elkridge in 1944. (Courtesy of the Merson family.)

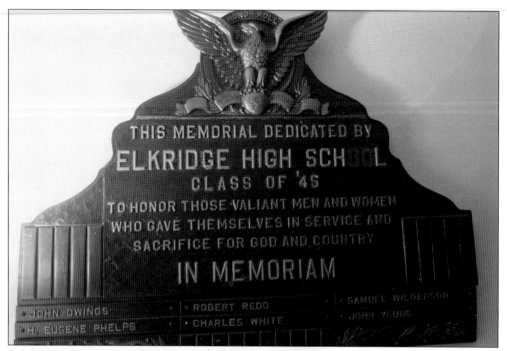

THIS MEMORIAL DEDICATED BY
ELKRIDGE HIGH SCHOOL
CLASS OF '45
TO HONOR THOSE VALIANT MEN AND WOMEN
WHO GAVE THEMSELVES IN SERVICE AND
SACRIFICE FOR GOD AND COUNTRY

IN MEMORIAM

JOHN OWINGS ROBERT REDD SAMUEL WILDERSON
H. EUGENE PHELPS CHARLES WHITE JOHN YOUNG

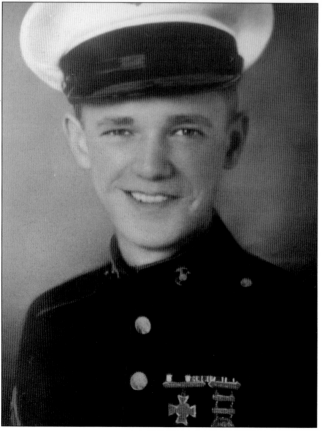

Elkridge lost several members of its community during World War II. A plaque honoring those who lost their lives from the class of 1945 at Elkridge High School was created and dedicated in their honor. It greets visitors in the entryway of the Elkridge Heritage Society. (Courtesy of the Elkridge Heritage Society.)

James Leo Schatz Jr. (1925–1944) of Elkridge died while serving in World War II. Private First Class Schatz was a member of L Company, 3rd Battalion, 1st Regiment, 1st Marine Division. He was awarded a Purple Heart after being declared missing in action in the Philippines on September 21, 1944. (Courtesy of the Elkridge Heritage Society.)

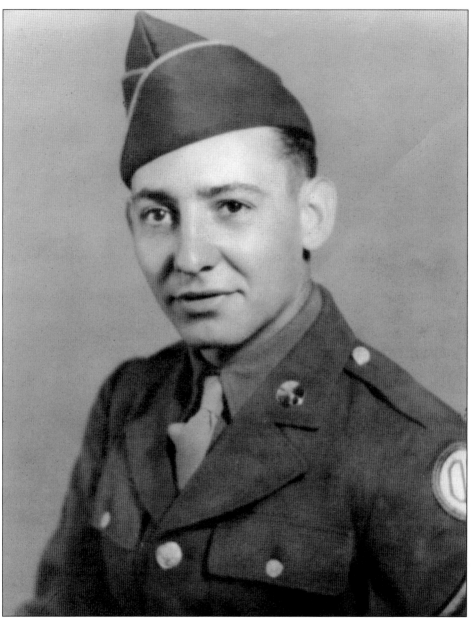

John Young, who lived on Railroad Avenue, died in 1945 in Manila, less than two weeks shy of his 28th birthday. He was a member of the 124th Infantry Regiment, 31st Infantry Division. Young had been in the service three years and just been named a sergeant when he was hit by flying shrapnel and killed in 1945. Posthumously, he was awarded a Purple Heart. "His family remembers John combed his hair straight back and that he smoked cigars," according to the curator of the Elkridge Heritage Society, who has researched his history. "He was known as easy-going, had a good sense of humor [and was] a quiet and gentle person. Though John did not own his own car, he charitably drove people, like the elderly, where they needed to go in their own cars. Up until time of service, he lived with his parents." He reportedly had never picked up a gun until the month before he left for war, but quickly became a skilled marksman. (Courtesy of the Elkridge Heritage Society.)

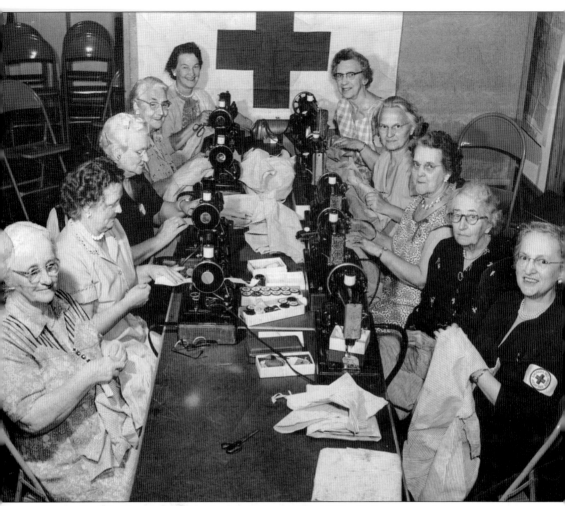

Women in Elkridge created a sewing circle during World War II. It was one of the ways citizens at home found they could be of service while their loved ones were overseas. This particular sewing circle stayed together for 30 years, according to the notes with this photograph, taken on June 15, 1956. Miriam Brumbaugh, wife of Elkridge doctor Bruce Brumbaugh, was the chair of the sewing circle, which was associated with the Red Cross. During World War II, the Red Cross was the major organization that handled wartime donations of sewing and knitting. Groups across America knitted quilts, bandages, socks, and sweaters for soldiers, with patterns provided by the Red Cross. Knitting became such a widespread way to give back that the November 24, 1941, issue of *Life* magazine features an article titled "How to Knit" so people who did not know how could learn and contribute to the war effort from home. (Courtesy of the Elkridge Heritage Society.)

Four

SANCTUARIES OF COMMUNITY

In 1857, St. Augustine School was founded on Old Washington Road. It was the first parochial school in Howard County and in the Archdiocese of Baltimore. Children are pictured outside St. Augustine after they receive their First Communion. Traditionally, children receive First Communion when they are between seven and eight years old, after completing religious study to ensure they understand the meaning of the sacraments. (Courtesy of St. Augustine Church.)

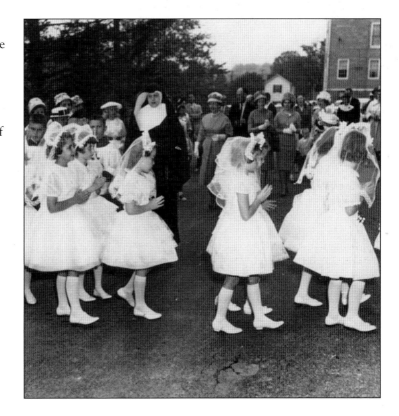

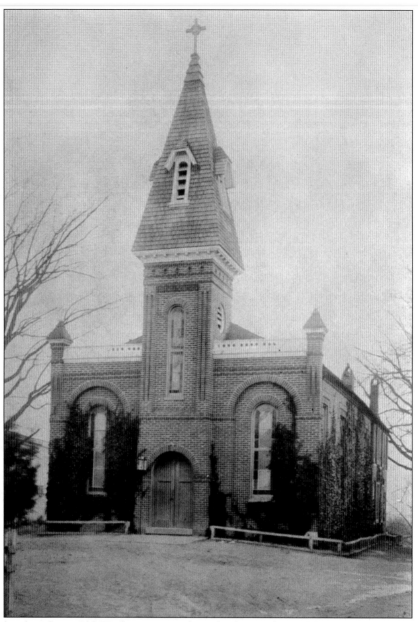

Before the church on Old Washington Road was built, members of the Catholic community in Elkridge met at each other's houses. When the actual church opened in 1845, it was still loosely organized. It did not have a resident pastor; instead, pastors from Ellicott City and Baltimore traveled to Elkridge to lead services at St. Augustine Church. The congregation consisted of people from greater Elkridge, hailing from Howard, Anne Arundel, and Baltimore Counties. From 1845 to 1846, Father Bernard Piot of Ellicott City led monthly gatherings at the church. Then, the Redemptorists of Baltimore, which worked with marginalized groups like Native Americans and immigrants, ministered to the congregation from 1847 to 1866. During that time, John Neumann—a Bohemian priest from New York who went on to be canonized as the fourth bishop in Philadelphia—was among those leading services. In 1866, the Archdiocese of Baltimore assigned the first pastor to the church. (Courtesy of St. Augustine Church.)

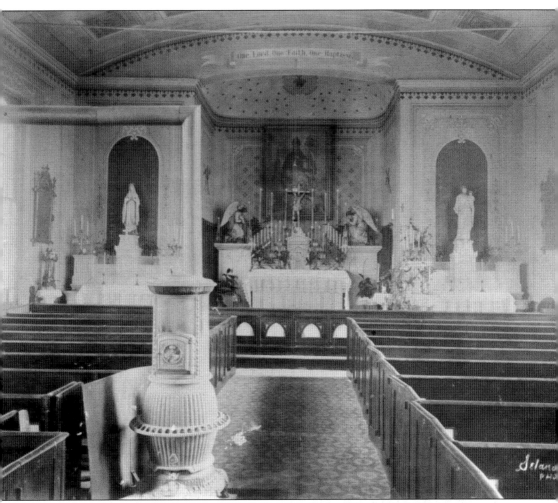

The first cornerstone of St. Augustine Church was installed in October 1844, and construction took six months. On April 20, 1845, Archbishop Eccleston, the fifth archbishop of Baltimore, officiated at the dedication of the new building, the interior of which is depicted here. In all, the church cost $2,200 to build. A potbelly stove in the aisle provided warmth. In 1895, with Fr. Francis Doory as its pastor, the parish celebrated its 50-year anniversary. Doory, a Baltimore native who studied at Loyola, St. Charles's College, St. Mary's Seminary, and Ellicott City, was appointed pastor of St. Augustine in 1894. Attendance had grown over the years, and in 1895, the congregation determined there was a need for a larger church. Fundraising began for a bigger space. Therefore, the St. Augustine Church in this picture was in existence for approximately 55 years before the new church was built. (Courtesy of St. Augustine Church.)

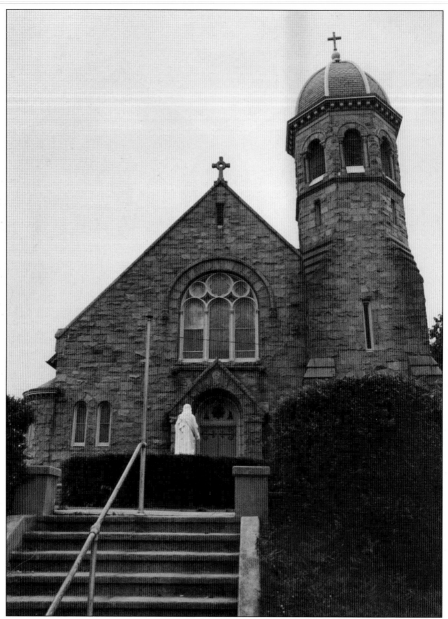

In 1894, the Catholic Elkridge Parish allocated money to build a larger church. More space was needed to accommodate the increasing number of those in attendance at services, which attracted worshippers from Anne Arundel, Baltimore, and Howard Counties. Therefore, 50 years after the first St. Augustine Church was constructed, a decision was made to begin work on the second iteration. The first church, built in 1844, cost $2,200 to build. Among those contributing to the cause for the second church were Sarah E. Boyle, John H. Shaab, Elizabeth Cook, and C.D. Kenny. The first cornerstone was laid May 12, 1901, and the new church was dedicated May 4, 1902. The project included expansion of not just the church but also the entire campus on Old Washington Road. After construction was complete, St. Augustine consisted of a convent, school hall, parochial residence, and church, and was valued at $50,000. By 1914, the congregation numbered 550 people. (Courtesy of St. Augustine Church.)

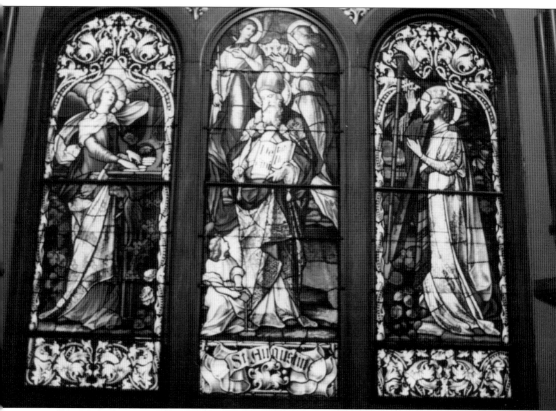

The stained-glass windows above the choir loft in St. Augustine Church were installed in 1901. To obtain the stained glass, St. Augustine's pastor at the time, Fr. Francis Doory, had them created and shipped from Innsbruck, Austria. In the left window is St. Cecilia, patron saint of the fine arts and church music; the Roman martyr is playing the organ, which is her signature symbol. At the center is St. Augustine, who was converted from living a life of sin to one dedicated to contemplation and worship; the experience began after Augustine cried out for help and a young boy directed him to read. To the right of St. Augustine is King David, who was the king of Israel and authored the Psalms, which were to be sung to music; as a result, he is often depicted with a lyre or harp. After the windows went in, Cardinal James Gibbons consecrated the new church on November 23, 1902. (Courtesy of St. Augustine Church.)

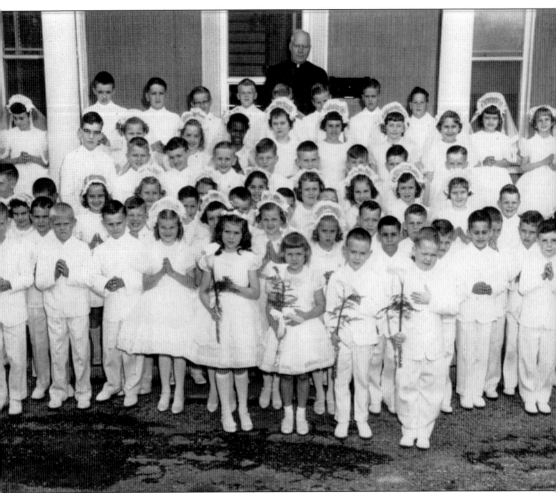

Founded in 1857, St. Augustine School was the first parochial school in the Archdiocese of Baltimore and in Howard County. The original schoolhouse had four rooms, and its students included children from Relay who walked across the Thomas Viaduct to go to class. One former pupil described the trip to school as scary, "like walking over air." Belgian priest Fr. Desiderius De Wulf founded St. Augustine School, which was at first run by priests. Among those heading up the institution in its first few decades were Revs. Thomas Broydrick, Joseph Cassidy, and John Conway. Then, in 1892, the Sisters of Notre Dame assumed leadership of St. Augustine School. By 1914, there were 55 boys and 50 girls at St. Augustine School. Over the years, the school grew, and the need for a larger space became more evident. As a result, a new school building was constructed. It was dedicated, along with the convent, in 1957. (Courtesy of St. Augustine Church.)

Pews were filled with children during their First Communion at St. Augustine Church. The photographer, Clement D. Erhardt Jr. of Baltimore, was prominent in his field, according to the *Baltimore Sun*, which reported that Erhardt covered events such as the riots after Martin Luther King was assassinated in 1968 and storm damage from Hurricane Agnes in 1972. He was known as a forensic photographer but was also commissioned by clients to cover a spectrum of subjects. Here, Erhardt captured a milestone for children at the Elkridge church; the first major event after baptism, First Communion marks a time when children are deemed grown up enough to understand and accept the sacraments. Girls, wearing veils, sit on the left. Boys are on the right. Wearing white symbolizes purity, and acceptance of the sacraments demonstrates the children have been educated about the Catholic way of life and are being initiated. (Photograph by Clement D. Erhardt Jr., courtesy of St. Augustine Church.)

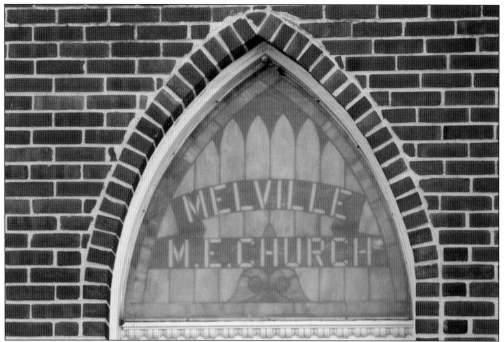

Melville Chapel was founded in 1772. It is among the oldest churches in American Methodism and was a stop on the circuit for evangelist John Wesley. In addition, the first Methodist bishop in the United States, Frances Asbury, stopped by for reflection and worship, according to his journals. In 1795, he wrote the following: "I preached and administered the sacrament on the Ridge. . . . We have a small society." The church was built in the Gothic style. A second Methodist chapel was built on Elkridge Heights but was later removed to make way for the B&O Railroad tracks. (Both, courtesy of the Elkridge Heritage Society.)

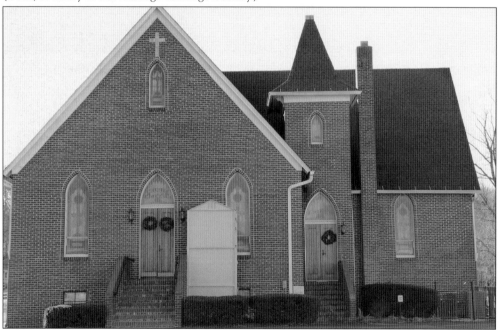

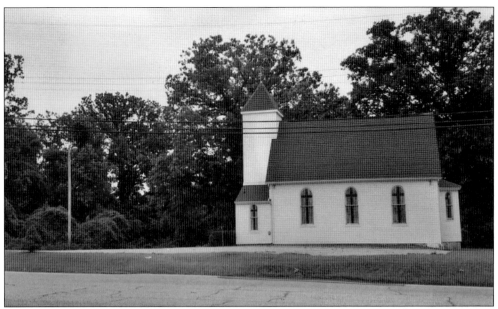

In 1866, James and Elizabeth Tyson of Baltimore County deeded a 1.5-acre tract of land known as Rockburn to the African Methodist Church of Elk Ridge Landing for a sum of $1. Initially, a church was built and called Providence AME Church. That burned to the ground and was replaced in 1883 by Gaines AME Church. A hall behind the church was built sometime between 1866 and 1878, intended as a school for black children. On Wednesday evenings in the summertime, Lawyers Hill residents could, according to one Howard County historian, reportedly hear the "singing voices coming from Gaines AME Church" during its midweek prayer, which added "particular enchantment to an already colorful area." (Both, courtesy of the Elkridge Heritage Society.)

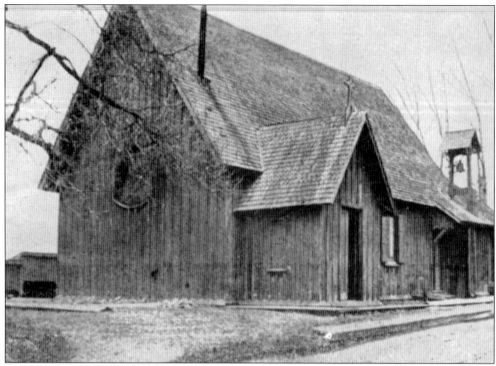

The first building of Grace Protestant Episcopal Church in Elk Ridge Landing was consecrated July 15, 1848. It burned November 22, 1855. (Courtesy of Grace Episcopal Church.)

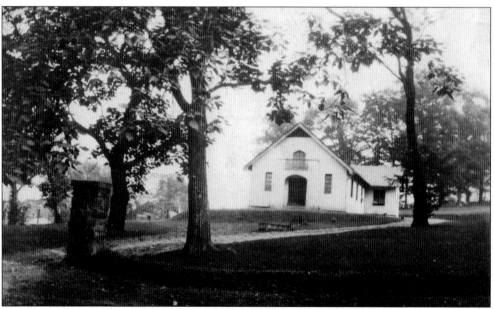

Between 1855 and 1909, Grace Episcopal Church had three fires, reportedly caused by sparks from passing locomotives. After the first church was built and burned to the ground in 1855, a second was built. Pictured is the parish hall of Grace Episcopal Church, also built of wood. (Courtesy of Daniel Carroll Toomey.)

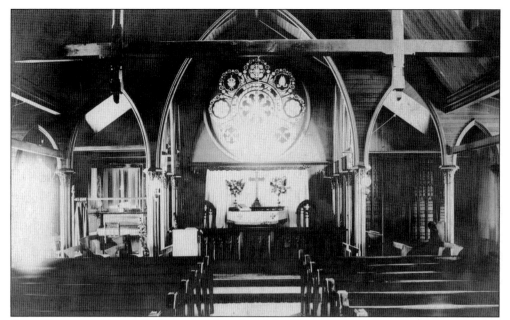

Grace Episcopal Church had two wooden church buildings burn to the ground. The interior of the one that is pictured was destroyed by fire on August 10, 1909. The church was built in 1856, and its successor—made of stone—was consecrated October 8, 1911. (Courtesy of Grace Episcopal Church.)

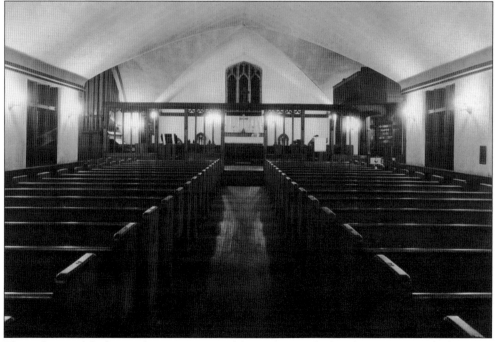

The architect of the longest-lasting iteration of Grace Episcopal Church was George Worthington, who lived in Elkridge with his wife, Louisa Blair. Built in 1930, the church on Main Street was placed up the hill from the railroad tracks and remains in use in the 21st century. (Courtesy of Grace Episcopal Church.)

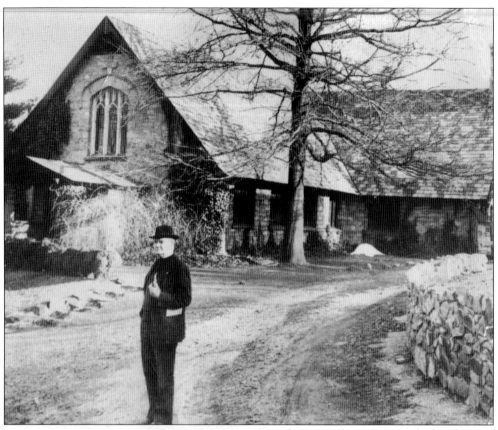

Over the years, Grace Episcopal Church expanded in new directions. In 1858, a Sunday school building was constructed on Main Street, and later, a parish house was built in 1960 on Montgomery Road at Landing Road. Each year during his tenure, Rev. Charles Durkee, pastor of Grace Episcopal Church from 1928 to 1954, sent a Christmas card to parishioners with himself pictured in front of the church. This has proven a useful tool in helping historians to trace the evolution of the stone church. For example, in one Christmas picture, there is a brick walkway, and in another, there is stone in its place. Durkee also engaged with parishioners by partnering with the community. For example, he began Grace Episcopal Church's sponsorship of Cub Scout Pack No. 432. (Above, courtesy of Grace Episcopal Church; left, courtesy of Daniel Carroll Toomey.)

In 1843, the Ellicott family deeded land on present-day Paradise Avenue for a church. Specifically, John, Mary, and Andrew Ellicott made the offer on Christmas Day that year. The stipulation was that it be used as a Baptist place of worship and burial ground for blacks. Before that time, the area had been used as a church and as a soldier's hospital. Upon the opening of Elkridge Baptist Church, it was the first Baptist church for blacks in Howard County. Relatives of initial members recalled that prominent individuals, including African American educators and civil rights leaders Booker T. Washington and Mary McLeod Bethune, visited for services at one time. "The Elkridge area was a depository for runaway slaves on the Underground Railroad because it was situated adjacent to the railroad tracks," according to the Elkridge Baptist Church's 161st anniversary program. The church was demolished by a fire in 1965 and rebuilt.

A sacred space came to fruition in the outdoors on Elibank Drive in 1901. It was designed to be a "cathedral garden" by a woman known as Mrs. Murray. A cemetery developed in 1929 and was called Cathedral Gardens. A house on the sprawling estate was designed by the Elkridge architect George Worthington; however, the home burned down in 1937. In approximately 1948, the Holy Trinity Russian Orthodox Church decided to relocate its headquarters to the space on Elibank Drive. Its chapel went in the space where the house had burned down, and its cemetery was installed behind it. The Cathedral Gardens property encompasses more than 55 acres.

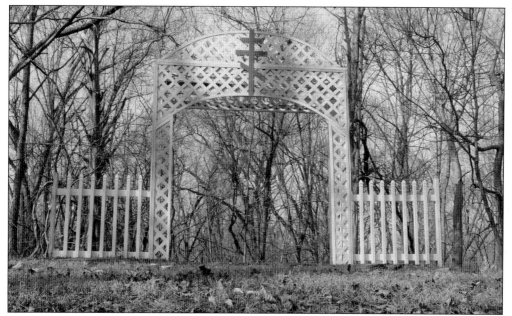

SS Peter and Paul Chapel of the Holy Trinity Russian Orthodox Church moved from Baltimore City to Elibank Drive in 1948. Some distance away from the chapel, the Russian cemetery that served its parishioners was located on a tract in Anne Arundel County. However, the land in Anne Arundel County was condemned as Baltimore officials sought to make way for Friendship International Airport. In 1947, the airport—which would later be called the Baltimore/Washington International Airport—began construction. It took the Holy Trinity Russian Orthodox Church approximately 18 months to transfer the graves from its previous site in Anne Arundel County to the new one on Elibank Drive.

Trinity on the Pike was consecrated in 1857 as an Episcopal church. In the beginning, it stood as a white clapboard church constructed for "farm families," according to the *Baltimore Sun*. Gradually, Trinity sprouted into a larger, more permanent structure along the turnpike. In 1867, the bell tower was added. In 1873, fire consumed the rectory, which was subsequently rebuilt. A stone extension was added onto the church in 1890, which included an altar and three stained-glass windows. In 1973, there was a divide among the parishioners as some wanted to move the church to a "more desirable location" instead of its spot on US Route 1, a rift that the *Baltimore Sun* reported cost the church half of its attendees. One Trinity member reportedly said, "It's on the Boulevard where we are needed. We are a little garden of Eden." (Both, courtesy of Trinity Episcopal Church.)

Five

SCHOOLS AND OTHER STRUCTURES

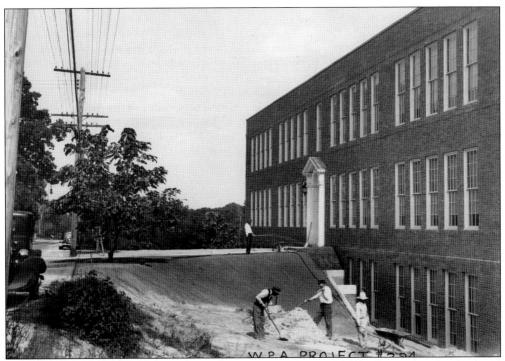

The Howard County Board of Education approved plans to build Elkridge High School in 1935 and allocated $41,250 for it. The project also received a federal grant of $33,750 through the Works Progress Administration (WPA), an initiative Pres. Franklin D. Roosevelt created to stimulate job growth during the Great Depression. Here, WPA laborers work outside Elkridge High School on Old Washington Road. By 1940, the WPA had constructed more than 4,000 schools. (Courtesy of the Enoch Pratt Free Library.)

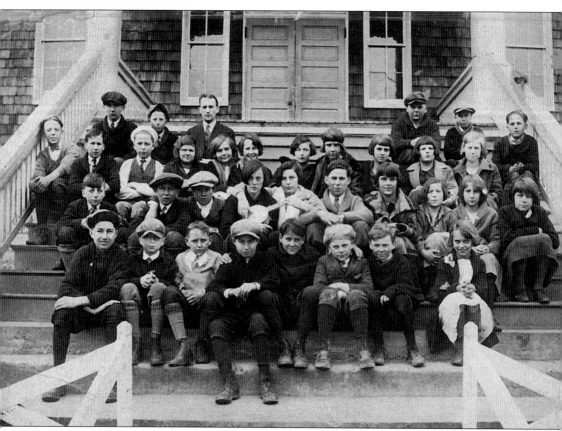

In a map of the area released in 1878, there is a schoolhouse north of the Belmont estate by the Patapsco River and another off the Washington Turnpike near present-day Montgomery Road. Schools often combined students of various ages and grades but were separated by race. The first high school in Howard County was for white students in Lisbon; it opened in 1899. As the population increased, the need for additional schools became more evident. By 1900, there were 60 schools for white students in Howard County and 14 for black students, according to the Maryland Historical Trust. According to Howard County Board of Education records, the minimum number of students required for a school to have a teacher in the year 1900 was 10, a number difficult to maintain at times due to infectious diseases like smallpox. For the school year 1900–1901, there were four teachers at white schools and one teacher for the black school in Elkridge. (Courtesy of the Howard County Historical Society.)

Children at Elkridge Elementary are pictured in 1919. Joseph C. Toomey, who lived in the old Elkridge Furnace house, is standing in the third row, against the wall on the left. (Courtesy of Daniel Carroll Toomey.)

The Elk Ridge Schoolhouse operated on Old Washington Road at Montgomery Road. It started functioning as a school as early as 1841, according to the Maryland Historical Trust, until the school board sold the property in 1912. There was also a school on Railroad Avenue. (Courtesy of the Elkridge Heritage Society.)

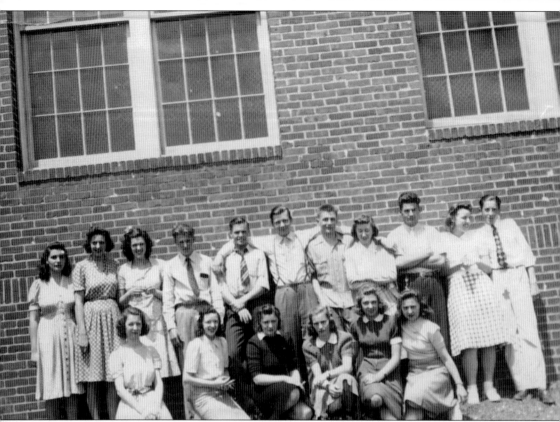

Cast members of the senior play at Elkridge High School have gathered for a group picture outside the school building on Old Washington Road. The senior play called *Boarding School* went on stage in approximately 1940. Charlotte Shaab starred, while Constance Sacker, Sherle Hastings, and Deloris Hartke costarred. In addition to theater, other extracurricular activities at Elkridge High School included an a capella club, field ball team, basketball team, bowling league, home economics club, glee club, newspaper club, electricity club, student council, dancing club, boys' shop, art club, and yearbook. The school opened in 1936 and was used until 1952, when Howard High School was built. The Elkridge High School yearbook was called *Reminiscing* and detailed the plot of the senior play; in *Boarding School*, the characters include Phoebe, the composition's leading lady; Kid Kenney, an ex-middleweight champion who was hired as Phoebe's bodyguard; and Cannonball, who "provided extra comedy to the play's presentation." (Courtesy of the Elkridge Heritage Society.)

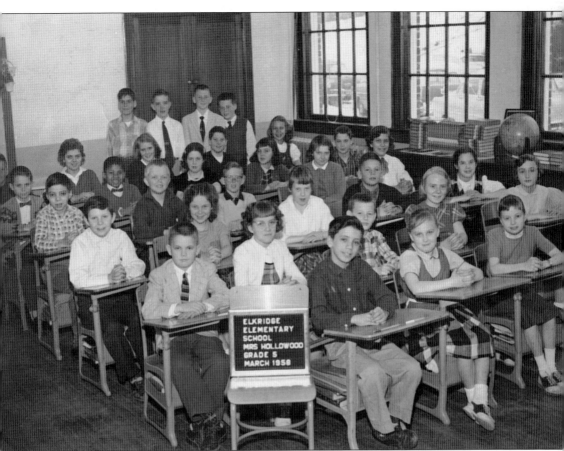

Elkridge High School was in existence until 1952, when Howard High School opened in nearby Ellicott City. After that, the building was used for Elkridge Elementary School. Pictured in Dora M. Hollowood's fifth-grade class at Elkridge Elementary School in March 1958 are, from left to right, (first row) Michael Gill, Joan Ferguson, and Dolores Owens; (second row) Ike Fleming, Judy Herman, Rodney Grove, Linda Frazier, and Patsy Medairy; (third row) Henry ?, and Bonnie ?, Jinny Voris, George Petrlik, and Mary Bahr; (fourth row) Raymond Hovermill, Billy Stevens, Mark Smith, Donna Robbins, and Martha Ward; (fifth row) Thomas Baker, Albert Stewart, Maureen Warner, Barbara Miller, and Richard Schilling; (sixth row) John Payne, Diane Kelly, Bobbie White, Kip Ledbetter, and Mary Gardner; (seventh row) Frank Buberyl, Thomas ?, Jimmy ?, and Anthony Seitz. The Elkridge Elementary School on Old Washington Road was vacated when a new elementary school opened on Montgomery Road in 1992. (Courtesy of the Elkridge Heritage Society.)

JUNIOR PROM

High School Auditorium Elkridge, Md.

Thursday, June 16, 1938

Charles Vincent's Orchestra

Time: 9:00 - 12 p. m. Subscription $1

It cost $1 to attend the junior prom at Elkridge High School in 1938. Jack Merson—who went on to become a professional baseball player after graduating from Elkridge High School in 1939—saved this ticket stub from the affair. A copy of his course schedule from his days as a student at Elkridge shows six periods, filled with classes like stenography, shop, and English. (Courtesy of Jack Merson.)

A graduate of Elkridge High School posed with her diploma. When the high school was built in the 1930s, students went from elementary school directly into high school. "Elkridge was a village," one graduate from the class of 1943 told the *Baltimore Sun*. "Our parents knew our teachers." The class of 1949 had approximately 41 people in it, the *Howard County Times* reported. (Courtesy of the Elkridge Heritage Society.)

Pfeiffer's Corner Schoolhouse was a one-room schoolhouse built in 1883. It sat on a hill along Waterloo Road near Mayfield Avenue and contained one room and a stove, according to the Maryland Historical Trust.

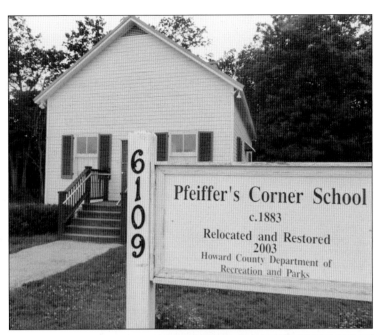

Until the 1930s, Pfeiffer Corner was used as a school. It was privately owned from the 1940s to 1988. Eventually, the Howard County Parks and Recreation Department moved the building from a storage space into Rockburn Branch Park, after a seventh-grade class from Hammond Middle School raised $16,500 to protect it from development.

The temperance hall on Main Street was constructed about 1815, according to the Maryland Historical Trust. Temperance halls presented alternatives to bars and taverns in the early 19th century as a place for recreation without the presence of alcohol. One member of the group Sons of Temperance was Jacob Dicus, an Elkridge man who lived from 1805 to 1876 and was known as "Honest Jake." He worked as a blacksmith by trade, loved playing the fiddle, had a wife and eight children, and was a practicing Methodist. In 1854, a group of men formed Howard Lodge No. 101 and rented the temperance hall's building for use as a Masonic temple. John Worthington was the lodge master, and members included Joshua McCauley, George Pocock, Stephen Bryan, Daniel Smith, Thomas Newton, F.M. Smith, Rev. S.W. Berry, and Jesse M. Lowe. Rent in 1869 was $20 and increasing. When Howard Lodge members discovered the temperance hall was for sale in 1893, they purchased it for $1,200.

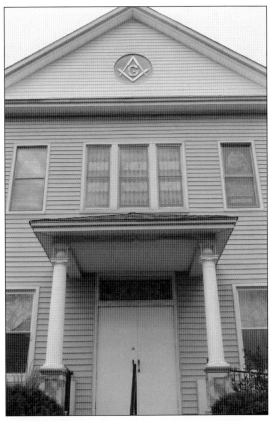

Members of the Masonic lodge in Elkridge built a temple on Levering Avenue in the early 1900s. Initially, the Elkridge brotherhood of Freemasons met in the temperance hall on Main Street; however, the group wanted to ensure it had space to grow and thus went to work constructing a Masonic temple on an empty lot. The first cornerstone of Howard Lodge No. 101 was laid in 1901 on Levering Avenue, and the building was dedicated in 1905. When the new temple first opened, the group envisioned a membership of 100. The lodge's membership by the end of the 20th century was more than 600.

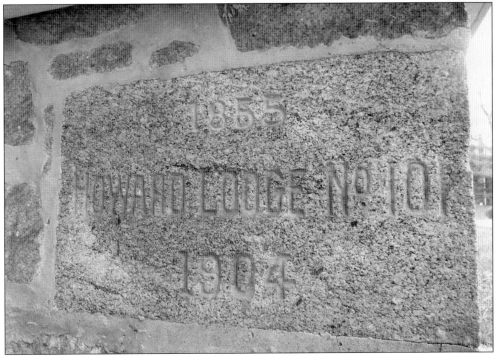

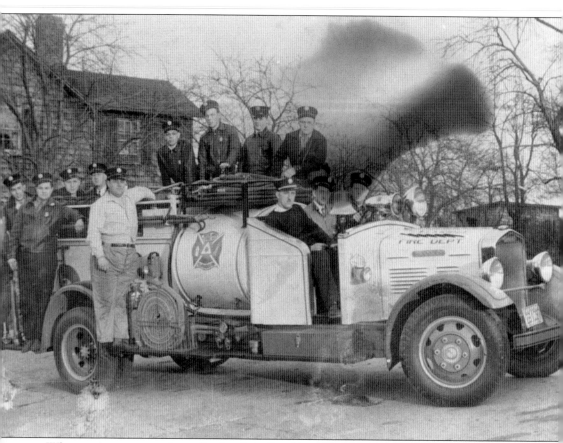

When news came over the radio that Pres. Franklin D. Roosevelt had declared war on Japan in 1941, some men in Elkridge left high school immediately to enlist, according to the *Baltimore Sun*. Those who remained at home wanted to help out as well, so many Elkridge citizens joined a civil defense effort that led to the creation of the Elkridge Volunteer Fire Department. Chief Edward P. Falter Jr. was the Elkridge Volunteer Fire Department's first leader. This picture was taken in 1942. Sitting in the front of "Daisy," the department's first fire engine, are, from left to right, Chief Ed Falter, assistant chief Kyle Lanahan, and engineer Ed Rehbein. Around them, from left to right, are Ed Liebman, Charles Rowles, Claude Hildebrand, Paul Carter, Mr. R. Skipper, Ray Skipper, Bud Merson, Bud Marks, Hammond Bosse, and "Howdy" Fuchs. (Courtesy of the Elkridge Heritage Society.)

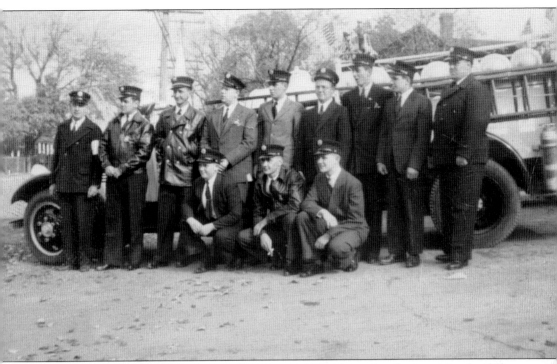

The Elkridge fire department's first engine, Daisy, earned Elkridge national recognition. In 1942, a group of citizens built Daisy from a 1934 truck found in a junkyard. "Daisy started to take shape, beginning with a truck body, siren, engine, and countless hours of work," according to an account published on a commemorative Daisy plate. An Elkridge farm owner donated the brass dinner bell he used to call workers for meals, and many men spent hours rebuilding the truck, which was kept at the end of one volunteer's Montgomery Road driveway. When the fire engine was complete, the director of the Office of Civil Defense presented the Elkridge Volunteer Fire Department with a citation for distinguished service in 1943, as Daisy was the first citizen-made piece of equipment under the auspices of the Office of Civil Defense. At the ceremony, Maryland governor Herbert R. O'Conor rode around town on Daisy, and afterward, NBC aired a radio program titled *Not for Glory*, detailing what the citizens of Elkridge had done. (Courtesy of the Elkridge Heritage Society.)

In November 1942, the first call the Elkridge firefighters received was for an air raid. Later that day, they responded to an incident in Dorsey, where woods on the property of J.H. Kane were on fire as the result of target shooting. In 1943, the citizens of Elkridge incorporated the department as an entity separate from the Office of Civil Defense. Chief Edward P. Falter Jr. was the department's first leader, serving from 1943 to 1950. The Elkridge Volunteer Fire Department consisted of an associate membership, active membership, and ladies auxiliary. Through events such as bingo and barn dances, the ladies auxiliary raised funds for things like equipment. In 1943, the auxiliary bought the building on Old Washington Road for $1,600 and presented it to the firefighters that May. (Both, courtesy of the Elkridge Volunteer Fire Department.)

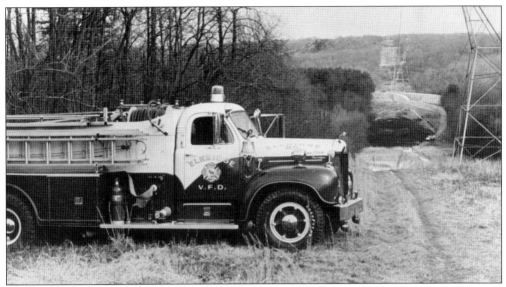

The Elkridge Motor Company used to be located at 6275 Old Washington Road, where the Elkridge Volunteer Fire Department established its headquarters in the 1940s. From its early days as a Ford dealership, the property changed owners and became a horse stable and riding facility. The owner of the stable agreed to let the firefighters use it for a monthly rent of $1, according to the Elkridge Volunteer Fire Department's history. In 1943, the Elkridge Volunteer Fire Department purchased the building for $1,600. "We must have shoveled out ten tons of horse manure," Ed Rehbein of Elkridge Volunteer Fire Department said after taking over the building. The account was documented in the fire department's 50th-anniversary history book, titled *Not for Glory*. (Both, courtesy of the Elkridge Volunteer Fire Department.)

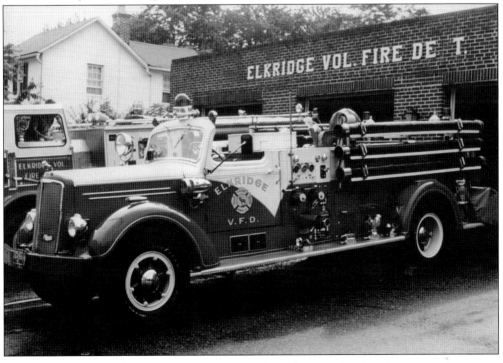

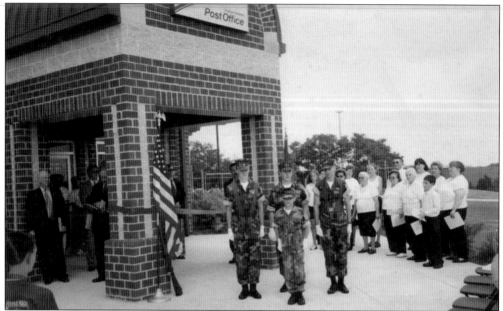

Elkridge got its own zip code, 21075, after a battle with the postal service in 1997. Previously, Elkridge was grouped with Baltimore and Halethorpe in the 21227 zip code. Here, at the 2000 grand opening of the Elkridge Post Office, Congressman Benjamin Cardin, left, delivers a brief speech while the young Marines stand at attention and members of the Elkridge Chorus prepare to sing. (Courtesy of the Elkridge Heritage Society.)

The Elkridge library was built in 1993. When Howard County made the decision to construct a library in the area in 1987, the plan was to build it on Bauman Drive at Montgomery Road, according to the *Viaduct*. That location, however, would not allow for expansion to include a senior center, so developers instead considered Washington Boulevard near Hunt Club Road, where the library was ultimately built.

Six

HOUSES OF HISTORIC ELKRIDGE

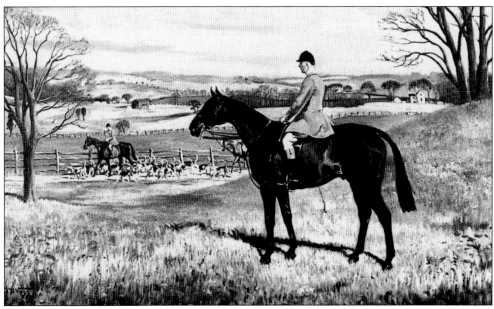

The Belmont estate was constructed in 1738, commissioned by ironmaster Caleb Dorsey for his son as a wedding gift. Pictured is an etching of foxhunters in a moment of pause on the Belmont grounds, which are sprawling hills on Belmont Woods Road. (Courtesy of the Howard County Historical Society.)

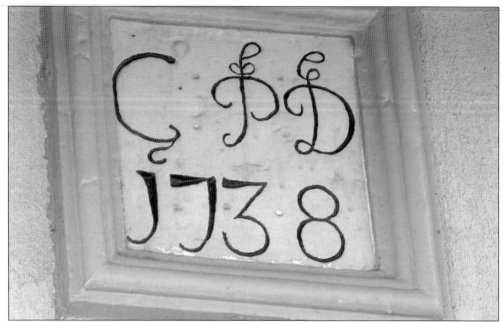

Caleb and Priscilla Dorsey married and lived in the Belmont mansion. Placards with their initials flank the front entryway to the Belmont manor house. At the time Belmont was built in 1738, as noted on the placards, Elkridge was a town in its infancy. After the Revolutionary War, more homes were added "with handsome grounds, flower gardens and gravel walks," according to the Maryland Historic Trust.

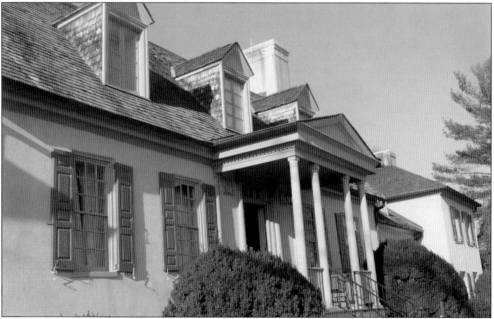

Belmont consisted of a farmhouse, manor house, carriage house, and guesthouse. The Dorsey family also owned many slaves. Narrow passageways in the house delineate the slave quarters from the other sections, such as the parlor and guest rooms. The house has more than a dozen guest rooms.

When Caleb and Priscilla Dorsey lived on the Belmont estate in the mid-1700s, it functioned as a colonial plantation near the various industrial operations Dorsey oversaw along the Patapsco River. The sprawling Belmont estate included a barn, carriage house, swimming pool, and gardens. In 1732, Caleb Dorsey Jr. received the land from his father as a wedding present. The gift included two parcels of property: Morning Choice, approximately 1,368 acres deeded from King William III to Mordecai Moore in 1698, and Dorsey's Chance, a 200-acre tract of land adjacent to Morning Choice. In 1738, the mansion where Caleb and Priscilla lived was built. Other parts of the land were used for things like mining.

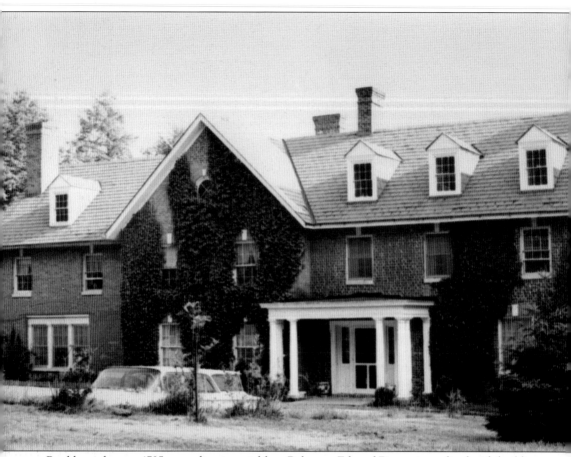

Rockburn dates to 1735, preceding its neighbor, Belmont. Edward Dorsey is credited with building Rockburn; he was the younger brother of Caleb Dorsey Jr., who lived at Belmont. Caleb Dorsey Jr. may have lived at Rockburn before Belmont opened in 1738, setting up shop before settling into his own house. At one time, the Dorsey family used the Rockburn mansion as an office for managing the furnace operations at Avalon, according to the Maryland Historical Trust. A private road connected Rockburn to River Road, along the Patapsco River. Rockburn was named for Rockburn Creek, which ran through the property. Rockburn was originally a one-story structure. As more space was needed, there were additions and more additions. Two wings were added in the early to mid-1800s, expanding it into a 22-room mansion. Fire in 1941 destroyed the south wing, which was later restored. (Courtesy of the Howard County Historical Society.)

The Knoll on Norris Lane was on property that, at one time, was part of Belmont. Elizabeth Cromwell Norris, whom historians describe as "a woman of means," constructed the Knoll as a rental property near her house, which was called Olney, off Landing Road in the late 19th century. Norris reportedly moved from Baltimore City to Olney to raise her children in 1879. She constructed the Knoll as a summer cottage to rent out for extra income. After building the Knoll, she noted in her diary that it was such a success that she planned to build a second rental property, which was called Banavie. Parts of Elkridge, like Lawyers Hill, became increasingly attractive to people for summer homes because they were away from the city and accessible from Baltimore by train.

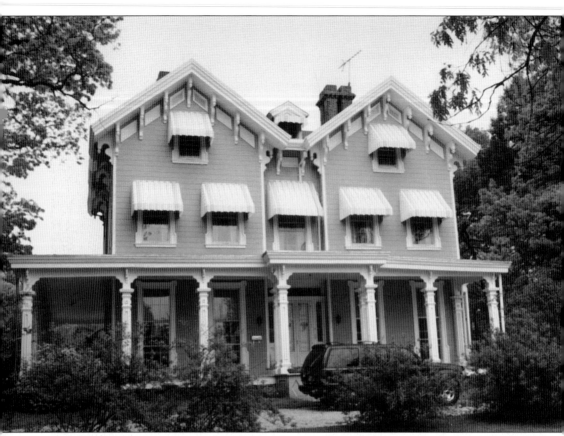

The Claremont mansion was built in 1858 on Lawyers Hill for George Gill, a prominent Baltimore lawyer. Architect R. Snowden Andrews, who planned the Church of the Redeemer on Charles Street and the Franklin Street Presbyterian Church rectory in Baltimore, designed the home, which sits on the southernmost part of Lawyers Hill. Claremont was known for its spectacular views of the Patapsco Valley. During the Civil War, soldiers camped on the property so they could guard the Thomas Viaduct. US brigadier general Benjamin Butler ordered two cannons set up in the backyard so his men could keep watch. Pictured is the Claremont estate from the front. In the 1940s, a man who grew up at Claremont became a real estate developer and proposed development of a subdivision on the Lawyers Hill property, according to the *Baltimore Sun*. (Courtesy of the Howard County Historical Society.)

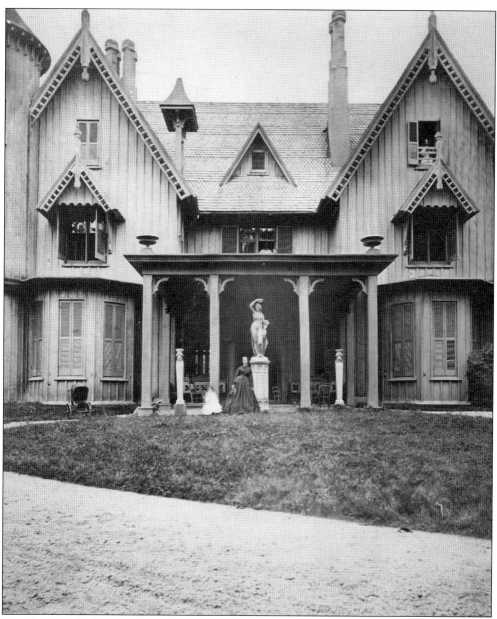

Fairy-Knowe, the house of John Latrobe, was built in 1843. Latrobe was a lawyer in Baltimore for the B&O Railroad. He was also an inventor who created a stove. For leisure, he wrote poems and, in one of his sonnets, he says that the environment around the Patapsco was "as pretty a place as there was in Maryland." After Latrobe's second wife, Charlotte, became ill, they decided to move to Lawyers Hill for rejuvenation. John Latrobe's brother was Benjamin Latrobe, the man who engineered the Thomas Viaduct. Their father, B.H. Latrobe Sr. was the architect who oversaw the construction of the Capitol in the early 1800s. When Fairy-Knowe was in its mid-19th-century heyday, the Elkridge estate was home to a windmill, icehouse, greenhouse, barn, and woodshed. It burned down in 1850 and then again in 1900. The barn, which had cast-iron stalls, survived the fires and later was converted into a residence. In 1937, a house was built in the Georgian Revival style near the entrance to the property. (Courtesy of the Maryland Historical Society.)

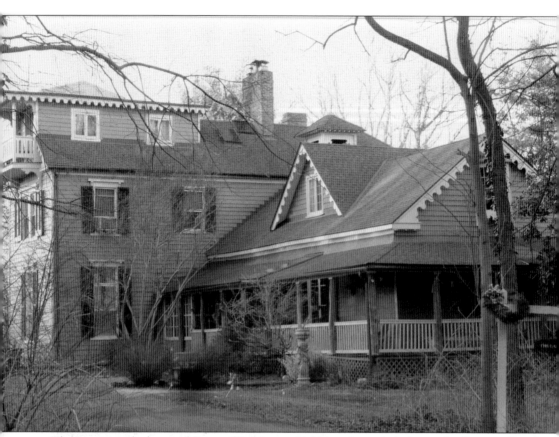

The Lawn was the home of George Washington Dobbin, who was a judge on the Supreme Bench for Baltimore City from 1867 to 1882. At one time, Dobbin was the dean of the University of Maryland Law School. His Elkridge home, built in 1842, was intended to be a summer retreat from the city. It was the first house constructed in what later became the historic district of Lawyers Hill—named for the profession that Dobbin pursued. In fact, the street that was in the 1920s called Old Lawyers Hill Road is referred to as Road to Dobbin House on maps in the 1800s. Dobbin modified the property several times within a 16-year span after building a simple rectangular home known as The Lawn—it was, after all, situated on more than 240 acres. As a result of the modifications, the home doubled in size. Among the additions were a library, three-story observatory, kitchen, two-story kitchen wing, enclosed porch, and double parlor. (Courtesy of the Elkridge Heritage Society.)

This pergola and rose garden was part of what was known as Cathedral Gardens on Elibank Drive. A house on the property burned down in 1938, and the Holy Trinity Russian Orthodox Church purchased the land in 1947 for its chapel, cemetery, and gardens. (Courtesy of the Smithsonian Institution, Archives of American Gardens, Garden Club of America Collection.)

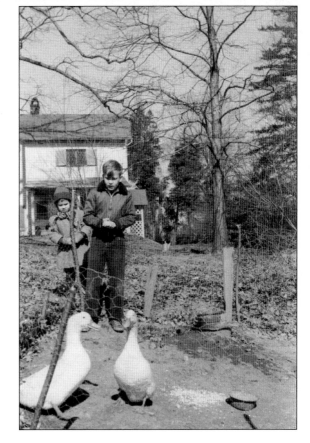

Mary and Leonard Bahr are pictured with their pet ducks in front of their home, Edgewood Cottage, on Lawyers Hill. This photograph was taken in 1966. The house was destroyed by fire in 1998. (Courtesy of the Elkridge Heritage Society.)

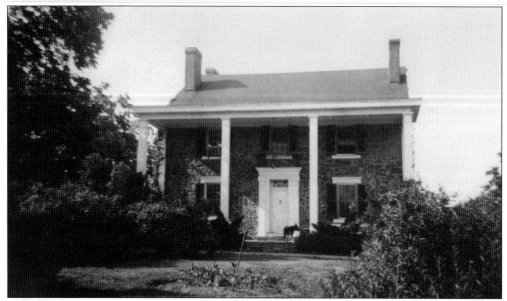

The Troy mansion was constructed around 1820, according to the Maryland Historic Trust. Vincent Baily, a farmer, purchased 652 acres of land from the estate of Thomas Dorsey in 1808. Thomas Dorsey was the grandson of Caleb Dorsey, who lived at Belmont. The land where Baily built his home was on a parcel delineated in land records as Troy. When Baily purchased it from the Dorsey estate, it was part of a "dwelling plantation," according to the National Park Service's Historic American Buildings Survey. Troy contained a farm, orchard, house, and henhouses. In 1971, the State Highway Administration purchased the land, which it intended to divide for the construction of Interstate 95. After public outcry, the Troy mansion was relocated rather than torn down. (Both, courtesy of the Howard County Historical Society.)

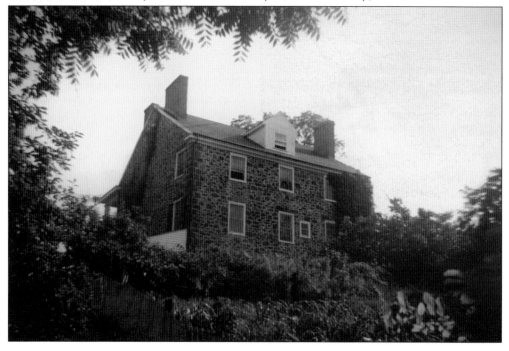

At right, Helen Lucy Toomey (left) and Katharine Toomey stand in front of the Elkridge Furnace, which transitioned from being a place of business to a family home in the early 20th century. The manor house was constructed around 1810 when the Ellicotts owned the furnace. The home was designed in a Federal/Greek Revival style. It contained 23 rooms and 12 fireplaces with details such as tiger maple spindles on railings. From 1904 to 1971, the Toomey family owned the 16-acre property. Below, an unidentified man poses for a picture in front of the Elkridge Furnace house on Furnace Avenue. (Both, courtesy of Daniel Carroll Toomey.)

At left, an unidentified girl stands in front of the icehouse next to the old Elkridge Furnace in a photograph dated April 9, 1939. During the winter, people would gather the ice from the river behind the house on Furnace Avenue and store it so they would have ice in the hotter months. Below, Barbara Ellen Toomey (1864–1924) and her husband, Joseph Henry Toomey (1858–1924) purchased this brick house on Furnace Avenue around 1900. It remained in the family for nearly three quarters of a century. (Both, courtesy of Daniel Carroll Toomey.)

Seven

DISASTERS AND DIVISIONS

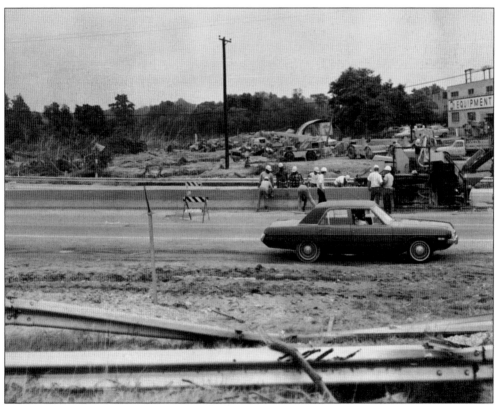

The flood of 1972 washed away businesses in Elkridge during Hurricane Agnes. The storm, which hit on June 21, was described as "the biggest natural disaster in Howard County's history," by the press. Commerce along US Route 1, pictured here, took a devastating blow, from which some businesses did not recover. (Photograph by Walter Hanson, courtesy of the Elkridge Heritage Society.)

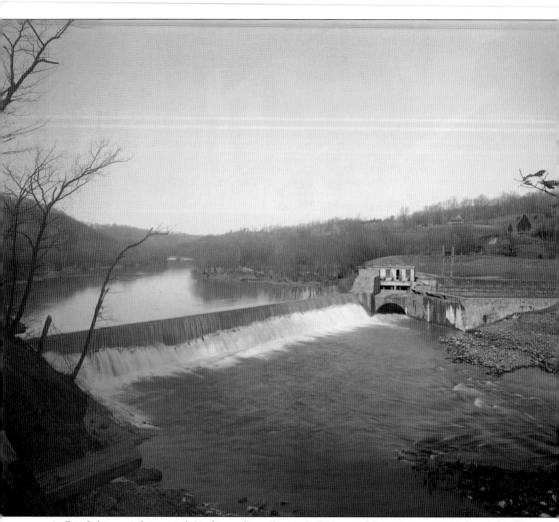

A flood destroyed most of Avalon, where Dorsey's Forge and later an entire industrial village were located. The flood swept away most of the buildings in 1868 when the Patapsco River's banks overflowed. Pictured are the remains of the Avalon Dam. The dam created power needed for operations at the forge, ironworks, and mill to work. Patapsco Valley State Park, founded in 1907, includes the site where the industrial hub used to be; it is now called the Avalon Area of Patapsco Valley State Park. One of two remaining buildings from Avalon became the Avalon Visitors Center. It was dedicated at the park in 2000 and was intended to educate the public about the area's history of industry in the Patapsco River valley. Before opening, the building required extensive restoration because in addition to the flood of 1868, it also was a victim of the 1972 flooding from Hurricane Agnes. (Courtesy of the Maryland Historical Society.)

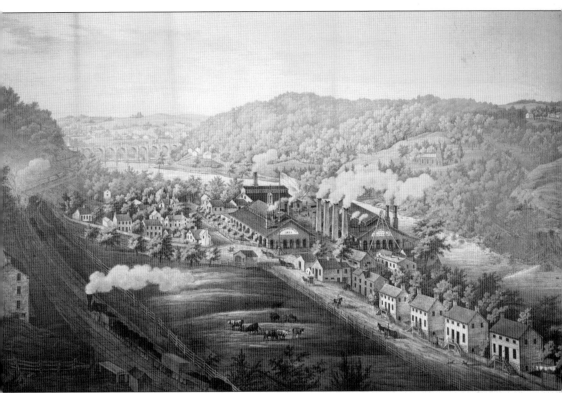

This lithograph of Avalon Rolling Mills—the industrial village founded by the Ellicotts—was drawn in 1858. After buying what was known as Dorsey's Forge in 1815, the Ellicotts renamed it Avalon Iron Works. With the advent of the railroad, the demand for iron was increasing. Avalon grew to include a rolling mill, nail factory, general store, church and homes. As of 1820, there were 24 nail-making machines on hand, and by mid-century Avalon employed more than 100 people. However, nature had other plans. In 1845, the nail factory folded after a fire. In 1868, a flood washed away the rest of the village. In the early 1900s, a businessman named Victor Bloede bought the property, which had been abandoned, and turned it into Avalon Water Works. This provided filtered water to Baltimore County and Baltimore City until 1928. The State of Maryland purchased the property in 1954 for Patapsco Valley State Park. In 1972, Hurricane Agnes swept away all but two buildings. (Lithograph by E. Sasche & Co., courtesy of the Hambleton Print Collection, Special Collections, Maryland Historical Society.)

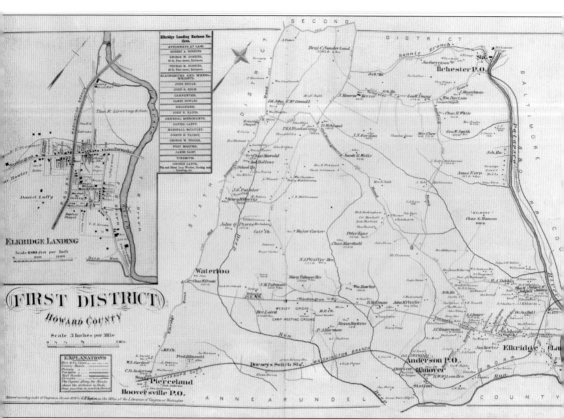

G.M. Hopkins drew this map of Elkridge in 1878 for inclusion in that year's atlas, which was compiled from surveys in and around Baltimore. In the earlier maps of Elk Ridge Landing, citizens lived closer to the water. Natural disasters prompted the people to settle farther away. In 1860, a flood took out some local businesses. In 1868, Elkridge went through the wringer as the dams that had been built to power mills along the river and the residents who settled in homes along the Patapsco peninsula were dealt a devastating blow. On July 24, 1868, "the mills and factories were all singing the usual song of cheerful industry, and the inmates of happy homes were busy with the ordinary routine of domestic employment, unconscious of serious danger, and perhaps smiling of the idea of its presence at their hearth stones," Hopkins recounted. The Avalon Nail Factory and the Hockley Forge were washed away forever. Thirty-nine people died in the storm. (Courtesy of the Library of Congress.)

96

This plat of Elkridge Landing shows the original layout of the town in the 1730s. A fire in 1825 reportedly destroyed nine of ten houses that made up Elk Ridge Landing at that time, according to the town's bicentennial journal. (Courtesy of the Elkridge Heritage Society.)

A flood swept away much of Elkridge in 1868, according to historians. This map of Elkridge in 1878 from the *Atlas of Howard County* shows the shift of residences away from the water and toward the railroad and turnpikes. (Courtesy of the Howard County Historical Society.)

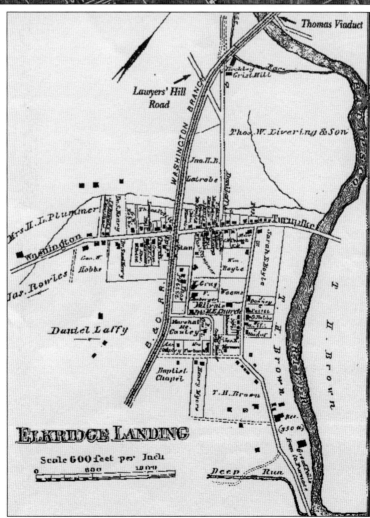

First Baptist Church on Paradise Avenue was 128 years old when it was destroyed by fire in 1965. A white carpenter was convicted of arson and sentenced to five years in the state penitentiary, according to the *Baltimore Sun*. While the church was being rebuilt, the parish found support from another Elkridge congregation. At the 1967 dedication ceremony for the new church, First Baptist extended its gratitude to the parish and vestry of Grace Episcopal Church, which "opened their doors to take us in 'as a witness to the world brotherhood in times of racial strife,' " according to the program handed out to attendees. In remarks before the Elkridge Heritage Society in 2002, First Baptist's pastor Monroe S. Simms recalled the progress made as follows: "There was a time when this community was highly segregated." Blacks lived on Race Road and Church Avenue and had to attend high school 30 miles away in Cooksville. "Elkridge has taken a tremendous turn from the days of Jim Crow," Simms said. "We've come a long way."

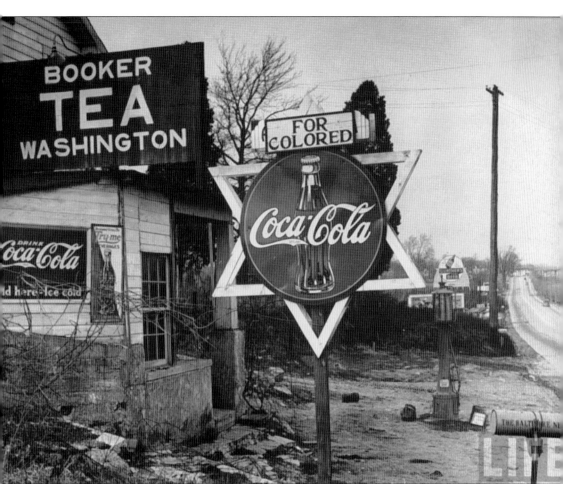

This photograph appears in the June 27, 1938, edition of *Life* magazine. The caption reads, "A negro rest station in Elkridge, MD." In 1935 the first black school opened in Howard County, the Cooksville School for Coloreds. Segregation was outlawed as a result of the Supreme Court case *Brown v. Board of Education* in 1954; however, Howard County was slow to move on the mandate to integrate schools and other facilities. It was not until 1965 that Howard County closed the all-black Harriet Tubman High School and began enrolling black children in schools closest to their homes, according to the *Baltimore Sun*. (Photograph by Margaret Bourke-White, courtesy of *Life*.)

In 1957, the Harbor Tunnel created a path for travelers between US Route 40/Pulaski Highway and US Route 1/Washington Boulevard on a toll road that transportation authorities said was the precursor to the beltway. Eventually, the Baltimore Beltway opened in 1977, spanning 52 miles; at that point, it was no longer a toll road. Also in the 1970s, Interstate 95 was extended to Elkridge, in a move many residents believed split the town in two. In 1971, Interstate 95 opened between the Baltimore Beltway (Interstate 695) and the Capital Beltway (Interstate 495). Between 1973 and 1974, an extension from the Harbor Tunnel linked Elkridge up with Interstate 95.

A man and boy look at the train wreck on Main Street in Elkridge. The tracks for the Baltimore & Ohio Railroad were laid in Elkridge in the 1830s; and by the early 1900s, railroads were the leading cause of violent death, claiming nearly 12,000 lives across the United States. In 1850, *Scientific American* offered the following tips for passengers to stay safe on the rails: "choose a center car, travel by day, and avoid foggy weather." The Elkridge area—where a train derailed in Dorsey in 1932—experienced the volatility of the rails before federal safety regulation began with the creation of the Federal Railroad Administration in 1967. (Both, courtesy of the Elkridge Heritage Society.)

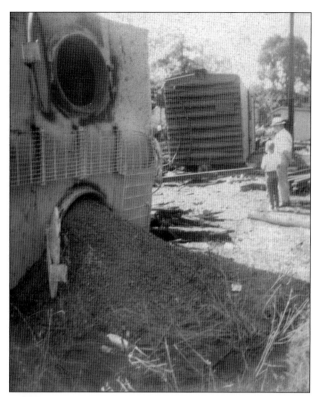

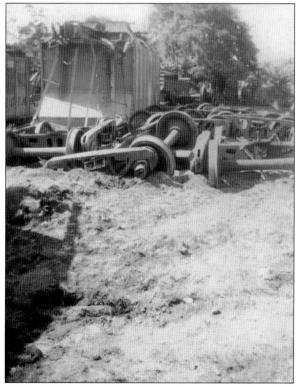

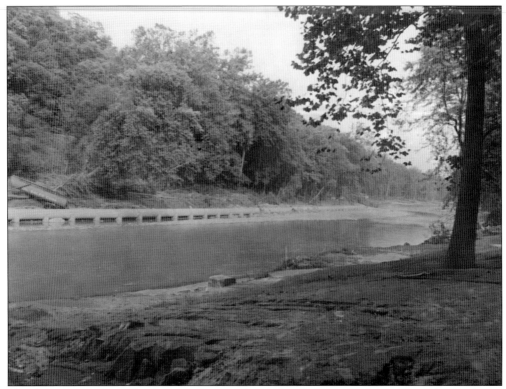

Floodwaters rose above the Patapsco River valley and spilled onto highways through Elkridge in the flood of 1972. As a result of the storm that hit June 21, 1972, more than 80 homes in Elkridge were damaged, according to "The Flood of 1972," an account from the *Times* newspaper released that year. (Photograph by Walter Hanson, courtesy of the Elkridge Heritage Society.)

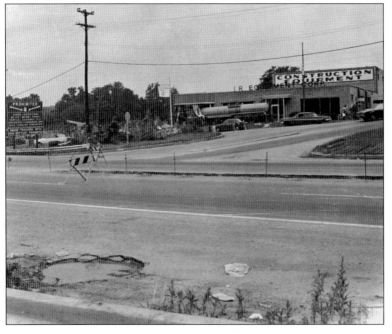

Some Elkridge residents were without power for a week after Agnes, newspapers reported, and seven cars that belonged to Elkridgeans washed away. Some businesses were not projected to recover for months. (Photograph by Walter Hanson, courtesy of the Elkridge Heritage Society.)

Eight

ATHLETICS AND ENTERTAINMENT

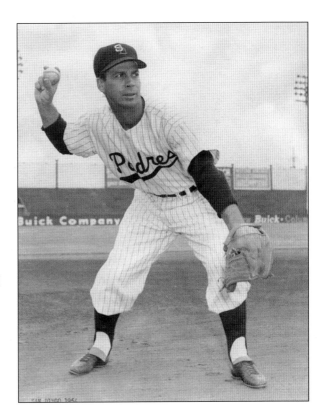

Jack Merson (1922–2000) graduated from Elkridge High School in 1939. He played for the Elkridge Athletic Club and later went on to get signed as a shortstop for the Pirates, the San Diego Padres of the Pacific Coast League, and the Boston Red Sox in the early 1950s. (Courtesy of the Merson family.)

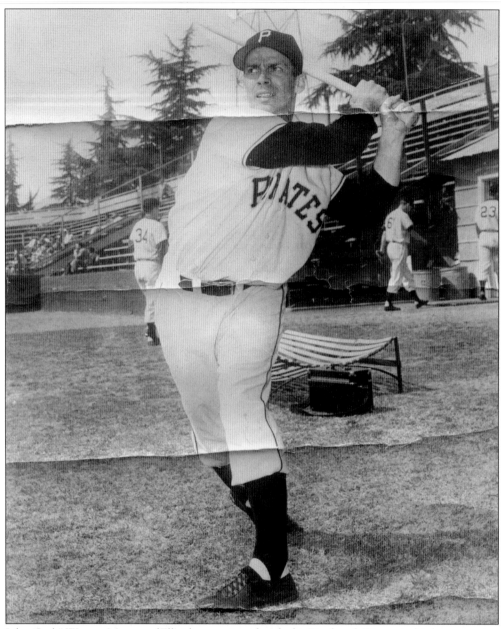

John "Jack" Warren Merson of Elkridge was signed with the Pittsburgh Pirates in his late twenties. He had played for the minor leagues before making the majors and served a tour in World War II. When he went into the service, he took six seasons off. Upon returning to the United States, the Elkridge native did not take long to get back into the game. First, he played for New Orleans (1949–1950) and Indianapolis (1951). Then, he signed with the Pirates at the end of the 1951 season. His Topps baseball card states that he was 5 feet, 11 inches tall and weighed 175 pounds. Merson, who had brown hair and brown eyes, was born January 17, 1924. Also according to his baseball card, Merson played second base for the Pirates and threw and batted right-handed. (Courtesy of the Merson family.)

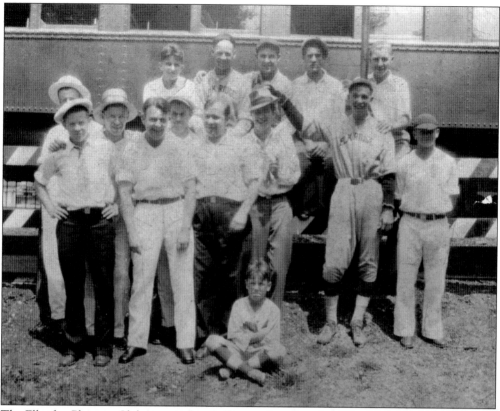

The Elkridge Pleasure Club was one baseball team that played in Elkridge in the first half of the 20th century. This picture was taken in 1929. (Courtesy of the Elkridge Heritage Society.)

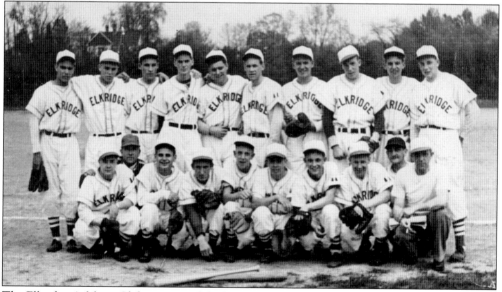

The Elkridge Athletic Club was one of the baseball teams that played in Elkridge in the first half of the 20th century. This team won the A.B.B. Middle Atlantic States championship in 1939 in Holyoke, Massachusetts. (Courtesy of the Howard County Historical Society.)

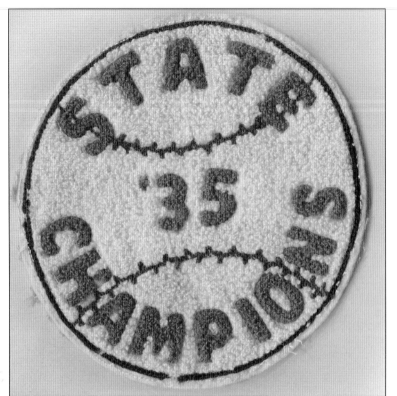

The players for the Elkridge Athletic Club received these emblems in recognition of the team's title as Maryland State Champions in baseball in 1935. (Courtesy of the Elkridge Heritage Society.)

Elkridge High School cheerleaders wore these letters on their uniforms. Elkridge High School ceased to exist after the construction of Howard High School in the 1950s. (Courtesy of the Elkridge Heritage Society.)

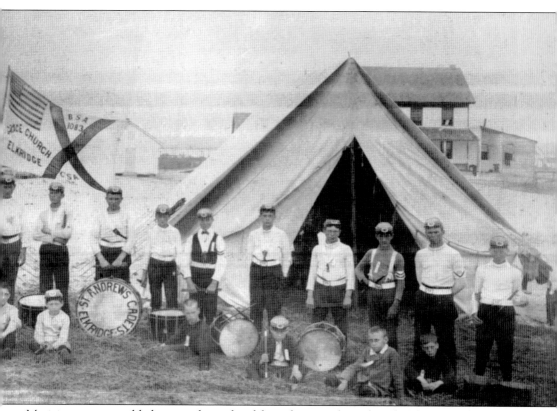

Musicians were sprinkled among the ranks of the military in the 17th and 18th centuries to boost morale. They also provided cues for routine activities like meals. According to music historians, the drum and fife music that the British played during the Revolutionary War became, for Americans, associated with their independence. As a result, around the time of the centennial and in post–Civil War America, drum and fife music drifted into popularity again in the United States. In America, the music became less rigid and took a turn toward the folksy. Local militias sponsored their own chapters of drum and fife groups. These children, shown with their instruments, are members of the Drum and Fife Corps of the Brotherhood of St. Andrew of Grace Church. Grace Episcopal Church of Elkridge has a long-standing tradition of working with youths. It has sponsored Cub Scout Pack No. 432 since 1949 and started the first kindergarten in Howard County. (Courtesy of Grace Episcopal Church.)

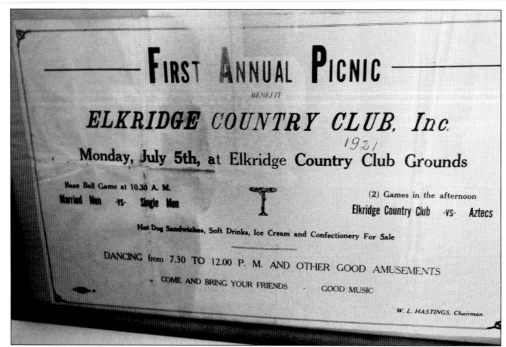

FIRST ANNUAL PICNIC

BENEFIT

ELKRIDGE COUNTRY CLUB, Inc.

1921

Monday, July 5th, at Elkridge Country Club Grounds

Base Ball Game at 10.30 A. M.

Married Men -vs- **Single Men**

(2) Games in the afternoon

Elkridge Country Club -vs- **Aztecs**

Hot Dog Sandwiches, Soft Drinks, Ice Cream and Confectionery For Sale

DANCING from 7.30 TO 12.00 P. M. AND OTHER GOOD AMUSEMENTS

COME AND BRING YOUR FRIENDS · GOOD MUSIC

W. L. HASTINGS, Chairman

The Elkridge Country Club was built in 1907 as a place for politicians and residents of Elkridge to socialize, according to the Maryland Historical Trust. It was the epicenter of Elkridge in the early 20th century, serving as a town hall. Sitting on Main Street at Levering Avenue, the house where the organization was headquartered contained one big open space. On July 5, 1921, the Elkridge Country Club held its first annual picnic. It also started sponsoring Elkridge Days, a yearly parade on Main Street that subsidized the group's expenses and supported youth sports and neighborhood efforts. Participation dried up during World War II, and the club disbanded. (Both, courtesy of the Elkridge Heritage Society.)

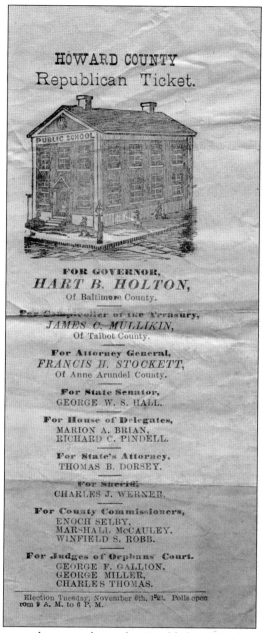

HOWARD COUNTY
Republican Ticket.

FOR GOVERNOR,
HART B. HOLTON,
Of Baltimore County.

For Comptroller of the Treasury,
JAMES C. MULLIKIN,
Of Talbot County.

For Attorney General,
FRANCIS H. STOCKETT,
Of Anne Arundel County.

For State Senator,
GEORGE W. S. HALL.

For House of Delegates,
MARION A. BRIAN,
RICHARD C. PINDELL.

For State's Attorney,
THOMAS B. DORSEY.

For Sheriff,
CHARLES J. WERNER.

For County Commissioners,
ENOCH SELBY,
MARSHALL McCAULEY,
WINFIELD S. ROBB.

For Judges of Orphans' Court.
GEORGE F. GALLION,
GEORGE MILLER,
CHARLES THOMAS.

Election Tuesday, November 6th, 1883. Polls open
rom 9 A. M. to 6 P. M.

Elkridge was the first election district and as such it "wielded major political influence in Howard County," according to Howard County historians. The Maryland Historical Trust reported that, in Elkridge, "a large number of its citizens played a role in day-to-day politics." Many influential men summered with their families on Lawyers Hill, named for the profession of those who stayed there. In addition, the Elkridge-Harford Hunt Club, which started near Hunt Club Road, attracted power players to the area. One of the most well-known politicians in the Elkridge circles was John F. O'Malley, who, in the early 1900s, was known as "the almost undisputed Democratic 'boss' of Howard County," according to *Elk Ridge: A Bicentennial Journal*. O'Malley was chief clerk of the tax commission for the State of Maryland. Pictured is a Howard County ballot from 1883. (Courtesy of the Elkridge Heritage Society.)

After its construction in the late 19th century, Lawyers Hill residents continued to support performances at the Elkridge Assembly Rooms. It had become a center for the Lawyers Hill community. Here, Lawrence and Mary Bahr of Edgewood Cottage are in costume with Rose Badart, right, before a performance in the early 20th century. (Photograph by Charles Patterson, courtesy of the Elkridge Heritage Society.)

Building the Elkridge Assembly Rooms cost $1,000 in the late 19th century, and families on Lawyers Hill financed its construction. They also became shareholders and contributed to its maintenance, with costs supported by ticket sales. Shows at the Elkridge Assembly Rooms cost 25¢ and up. The performances became increasingly popular and attracted an audience from Baltimore. (Courtesy of Mollie and Anna Boyd.)

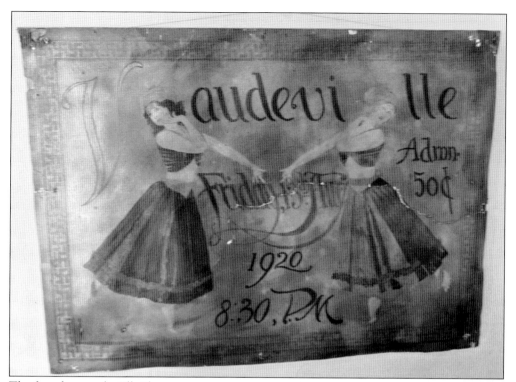

The first show at the Elkridge Assembly Rooms was *The Rivals* in 1870, and the last was in 1992. For the first show, actors and actresses got dressed at The Lawn, as their dressing rooms and the entire assembly hall were not yet complete. In the first decades of the 20th century, residents from the Lawyers Hill community performed cabaret and vaudeville in addition to plays like *Beauty and the Beast* and *Mr. Bob*. Handwritten lists inside the hall name members of committees that provided entertainment in addition to theatrics there—the events, games, and baseball committees were a few. Card parties and Fourth of July festivities were especially popular. (Both, courtesy of the Elkridge Assembly Rooms.)

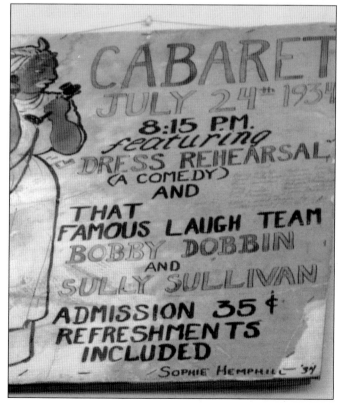

The Elkridge Drive-in came onto the US Route 1 scene in 1948. It was one of a handful of theaters in the area—there was another screen in Catonsville off Edmondson Avenue. In 1985, with the rise of enclosed movie theaters and property values increasing, the Elkridge Drive-in closed. In 1987, a windstorm reportedly knocked the drive-in's screen down. (Courtesy of the Maryland State Archives.)

Elkridge Days was a parade held annually to celebrate the town for which it was named. Pictured at the parade on June 25, 1978, are, from right to left, Maryland comptroller Louis L. Goldstein, Kenneth England (dressed as "Uncle Sam"), and an unidentified gentleman. (Courtesy of the Maryland State Archives.)

Nine

US ROUTE 1 CORRIDOR

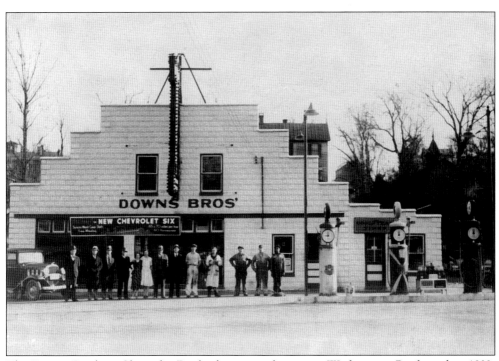

The Downs Brothers Chevrolet Dealership was a fixture on Washington Boulevard in 1932. Pictured are, from left to right, unidentified; Howard T. Downs, owner; Emil Ford, salesman; J. Frank Harman, office manager; Etta Link, office help; Louise Perry, office help; unidentified; Charles P. Downs, owner; Earnest Hicks, mechanic; J.C. Toomey, parts manager; C. Davis, mechanic; Warren Stern, mechanic; and Sherman West, general help. (Courtesy of Daniel Carroll Toomey.)

Some Elkridge residents were employed by the railroad as it boomed along in the 1800s. Pictured, Lee Enoss of Furnace Avenue worked as a baggage handler at Relay Station. (Courtesy of Daniel Carroll Toomey.)

In the early 1900s, merchants and general stores were the businesses of the day. Charles Adam Hartke, who owned a general store on Old Washington Road, is pictured on a trip aboard the USS *Dolphin* with his wife, Ida Mae, and their two children, Nellie and Lester. Another business near their home was the Elkridge Pharmacy, erected around 1930. Next door to that was "Pop" Hubbard's ice cream store and saloon, with living quarters upstairs. (Courtesy of the Elkridge Heritage Society.)

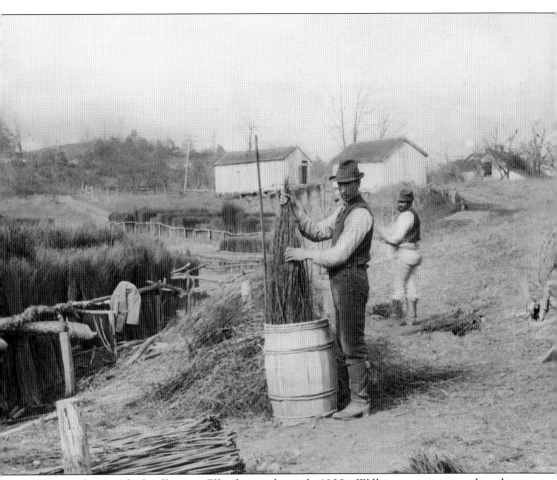

Here, men have picked willows in Elkridge in the early 1900s. Willow groves emerged as the commercial landscape shifted at the turn of the century. In the early 19th century, a millrace, or channel for driving water, was built from Deep Run to Furnace Avenue. The plan was to create a current that could power the Elkridge Furnace. However, as trade became increasingly difficult due to tariffs, the iron industry went belly-up. In 1850, the Ellicotts declared bankruptcy. With the passage of time, the flooding of 1868, and new ownership, the furnace operation eventually became dormant. Willow shoots sprang up along the path that had previously been the millrace, and workers plucked the willows, which they fashioned into wicker baskets. By the 1920s, the willow gardens, too, had faded. The area where the millrace and willows had once been was filled in and called Race Road. (Photograph by the US Forest Service, courtesy of the Maryland State Archives.)

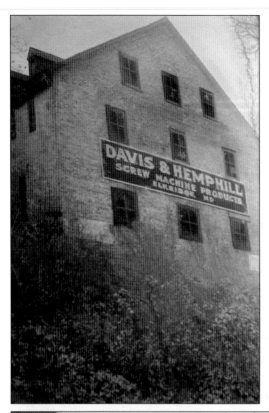

Marion Davis of Lawyers Hill founded Davis & Hemphill in 1909, according to the Maryland Historic Trust. The manufacturing company opened a factory in Elkridge in May 1916. The building on Furnace Avenue at Race Road had previously been employed as a flour mill for more than 100 years, according to the business owners.

Davis & Hemphill employed many Elkridge residents. The company manufactured screws for high-powered machinery and hand grenades, among other things. It was located on Furnace Avenue at Race Road. Pictured are employees in front of the factory. (Courtesy of the Elkridge Heritage Society.)

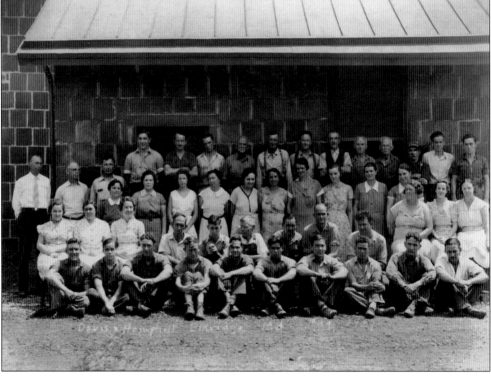

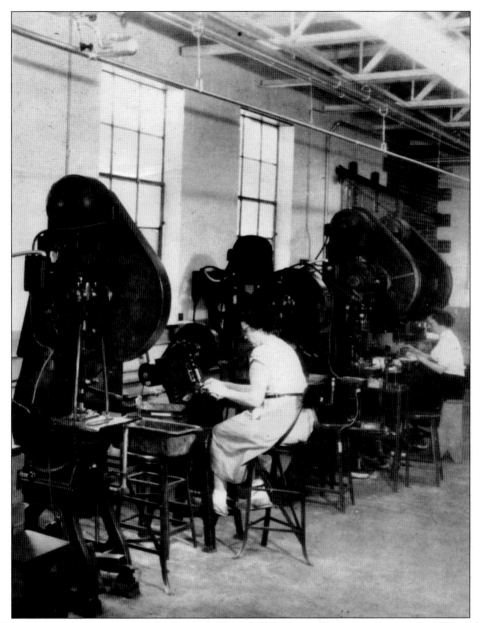

Women sit at their stations in the Davis & Hemphill factory off Furnace Avenue. In 1914, only about three percent of the workforce in the United States consisted of women, but the number of women working in factories grew exponentially during wartime. After the country entered World War I, companies were not just manufacturing their traditional products but were also fulfilling wartime requests needed by the troops. "The women of America must be given credit on account of the highly important part they took in this phase of helping to win the war," Benedict Crowell, the assistant secretary of war, wrote in a report to the War Department after World War I. He said that 19 of 20 people working in grenade factories were women. "In fact," he wrote, "no other item in the entire ordnance field was produced so exclusively by women." In Elkridge, the Davis & Hemphill factory manufactured screws that were used in things like grenades as well as household appliances. (Courtesy of the Elkridge Heritage Society.)

This sign on Washington Boulevard was shaped like a chow in honor of the business owners' dog. The company sold flea killer but was known for its unique presence on US Route 1. This picture was taken sometime in the 1940s or 1950s. (Courtesy of the Maryland State Archives.)

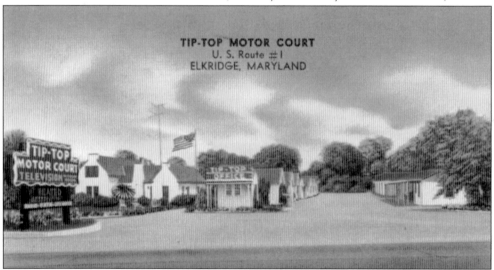

On this postcard that is postmarked 1953, the Tip Top Motor Court promotes the fact that it is "six miles south of the Baltimore City line" and "air-conditioned," with Beauty Rest mattresses, televisions in every room, and "city water." Motor courts grew in popularity as the automobile became more attainable. In 1931, there were 30,000 motor courts nationwide; by 1956, there were 60,000.

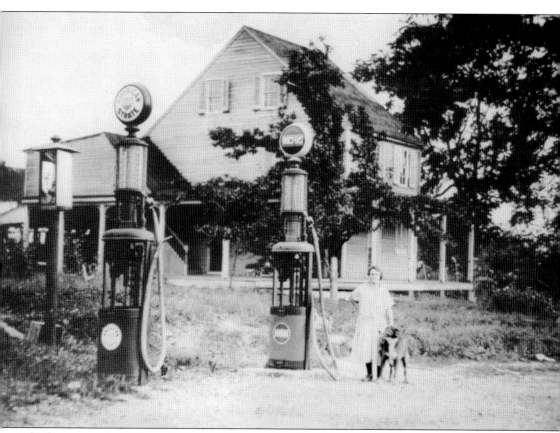

The first gas station in America reportedly opened in Seattle in 1907. Early gas stations consisted of service pumps, a primitive model that stayed in existence through the 1920s. These gas pumps on Old Washington Road were reportedly the first ones between Baltimore and Washington. With more automobiles hitting the road as the years went on, there became more competition among gasoline vendors. Over time, businesses began relying increasingly on signage and brand identity to encourage customers to buy their gas. Gulf Oil was the first to commission an architect to design its stations, the first of which opened in 1913 in Pittsburgh. By 1920, the price of gas was 30¢ per gallon. By 1950, it was 27¢, as "gas wars" drove sellers to come down on their prices. (Courtesy of Cindy Quick.)

Charles A. Hartke owned a general store on Old Washington Road near the intersection with Montgomery Road. He was one of several Elkridge store owners in the first decades of the 20th century. Near the railroad tracks by Main Street, there was a drugstore, hardware store, lumberyard, coal yard, general store with a feed room, and another with a post office. There was also a meat store, shoemaker's shop, and grocery store. Hartke's store was one of three buildings on Old Washington Road that dates to 1850 or before, according to Howard County planning records. The Hartke property included a house and two outbuildings, one of which may have housed animals. Here, Hartke is pictured in 1920 with his cow. He also had two dogs named Brownie and Jack, each of whom required a $100 permit to own in Howard County. (Courtesy of the Elkridge Heritage Society.)

Goody's Decoys and Folk Art set up shop on Main Street in a building "reputed to be the custom house for Elk Ridge Landing," according to Howard County archival reports. In the late 1800s, the building housed Pocock's Store, according to the 1876 *Hopkins Atlas*, when the road was the Washington Turnpike. The couple that owns Goody's Decoys and Folk Art, Harold and Anna Goodman, restored the interior of the building on the 5700 block of Main Street. They sell handmade decoys, woodwork, and embroidery.

Daniels Restaurant and Bar on US Route 1 opened in 1975. When Emily Daniels purchased the building along Washington Boulevard, just north of Old Washington Road, she bought it with her husband, Dan. At the time, the property was a home (pictured below). Although it was converted into a restaurant and operated as a business, it still managed to retain a home-style atmosphere. Daniels Restaurant and Bar has been open 365 days a year ever since it opened in 1975. Each year, the restaurant participates in many charity rides (pictured above) and other benevolent efforts through its patrons. (Both, courtesy of Daniels Restaurant.)

Due to its location along the highway, Daniels has attracted many motorcyclists. It has also been known to welcome horses to take a load off and rest their hooves at the end of the open-air bar. Daniels Restaurant and Bar is known for its acceptance of all people and for its home-style atmosphere and food. It is also the only establishment in Howard County that has an outdoor liquor license, according to the *Baltimore Sun*. There is one rule that is strictly enforced: no swearing. (Both, courtesy of Daniels Restaurant.)

The Elkridge Corners shopping center is at the corner of a triangle of Elkridge family businesses. Here, construction begins on Cindy's Soft Serve, which sits on the fringe of the shopping center along Washington Boulevard. According to the *Baltimore Sun*, the shopping center opened in 1990. Cindy Quick, for whom Cindy's Soft Serve is named, launched the ice cream stand in 1992. She later sold it to her father, Claude Sacker, who also owns the Hillside Motel to the left of Cindy's Soft Serve. With her husband, Tom, she started Cindy's Liquors, which is located within Elkridge Corners shopping center. (Both, courtesy of Cindy Quick.)

Cindy's Soft Serve opened on US Route 1 in 1992. The ice cream kiosk quickly became a staple of the Elkridge community, where residents cannot wait for it to open each year. The ice cream operation closes in October for winter and reopens in April. "It's not spring until Cindy's opens," many Elkridge residents believe. Specials at Cindy's Soft Serve include the snowball with a marshmallow inside, any flavor of its ice cream, and milk shakes. Lines typically form in the summer; the ice cream stand functions as a popular hangout for children and families. (Courtesy of Cindy Quick.)

The US 1 Flea Market on Washington Boulevard opened as a weekend attraction, selling everything from live chickens to tennis shoes. There were 70 stores inside the flea market complex on Washington Boulevard. On Saturday and Sunday mornings, the space outside the flea market complex turned into an open-air bazaar. Throngs of Hispanic families shopped at the market, which housed an indoor food court with items like *pupusa* and *horchata* on the menu. Outside, exotic pets, power tools, and religious icons were among the items for sale. The land where the US 1 Flea Market was located became increasingly valuable as residential developments peppered the highway.

When Gary Kaufman and his wife, Judy, ran a funeral home on Furnace Avenue at Main Street. They were members of Melville Chapel, and he was on the Howard County Planning Board. In 1984, they hosted their first funeral, and for a time, it was the only funeral home in Elkridge. Later, the couple decided to sell the house and move the operation to land available near Meadowridge Park. It became known as the Gary L. Kaufman Funeral Home at Meadowridge Memorial Park in the following years. Back on Furnace Avenue, chef Dan Wecker purchased the Elkridge Furnace property in 1989. He rehabbed the building and converted it into a restaurant, which he called the Elkridge Furnace Inn. The fine-dining restaurant has won accolades for its food, wedding services, and events. (Below, courtesy of the Elkridge Furnace Inn.)

Discover Thousands of Local History Books Featuring Millions of Vintage Images

Arcadia Publishing, the leading local history publisher in the United States, is committed to making history accessible and meaningful through publishing books that celebrate and preserve the heritage of America's people and places.

Find more books like this at
www.arcadiapublishing.com

Search for your hometown history, your old stomping grounds, and even your favorite sports team.